Minnesota in Our Time

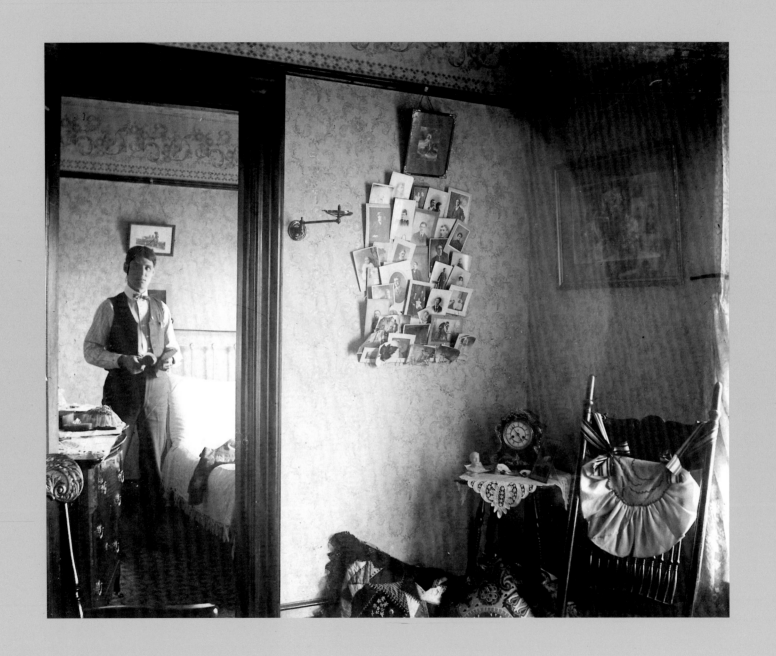

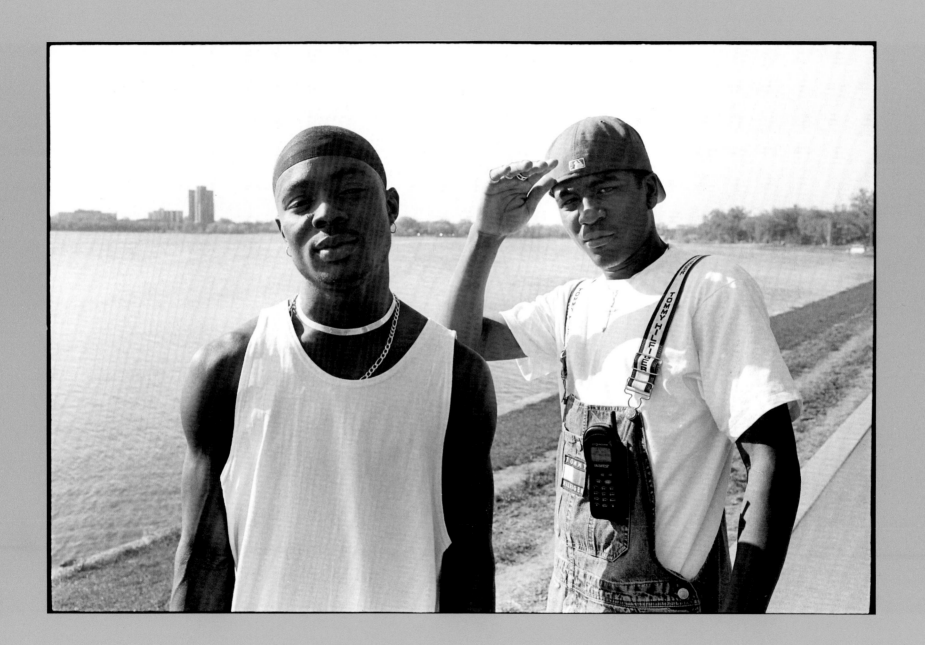

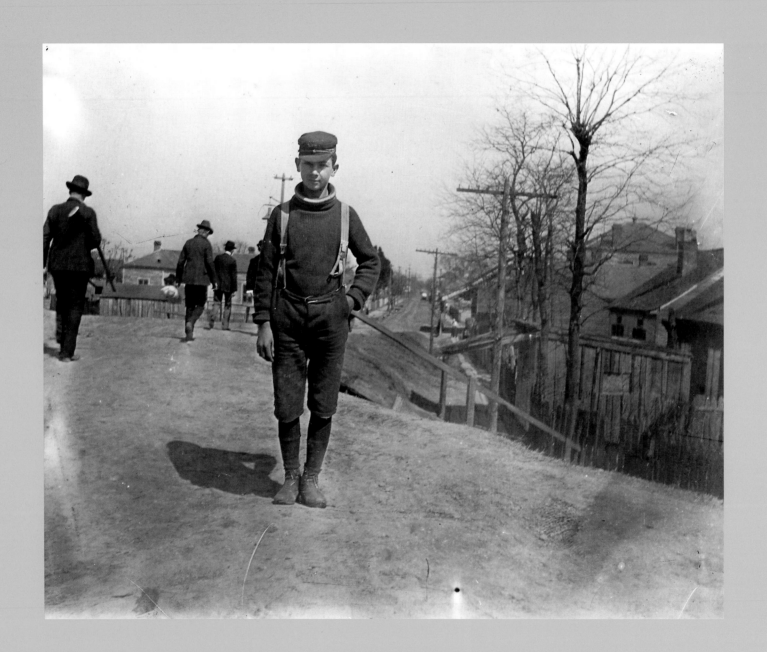

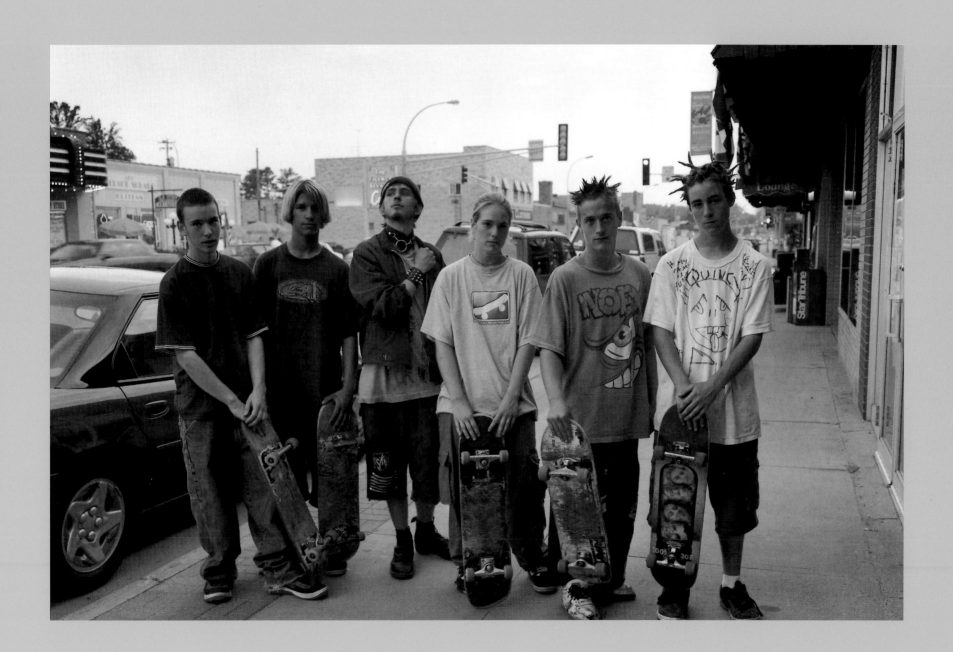

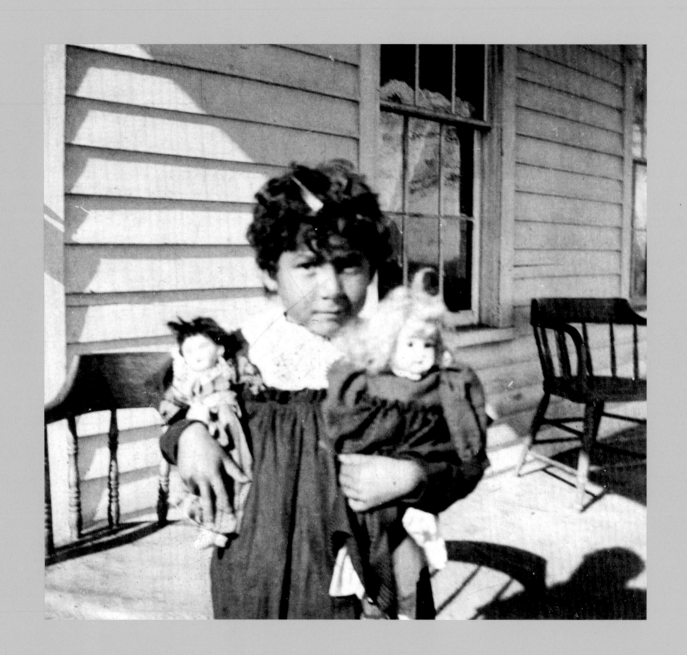

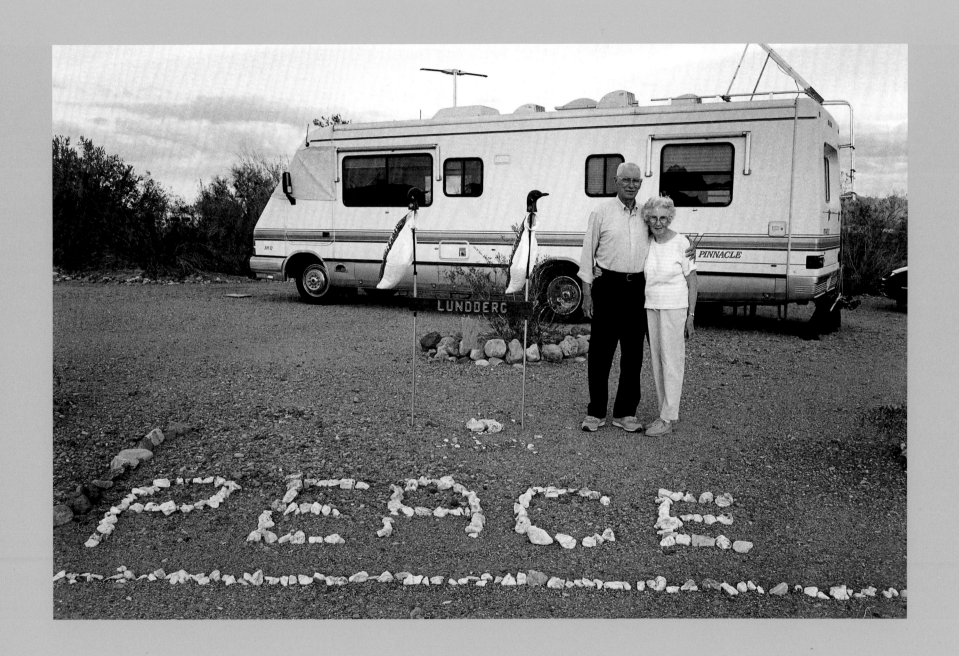

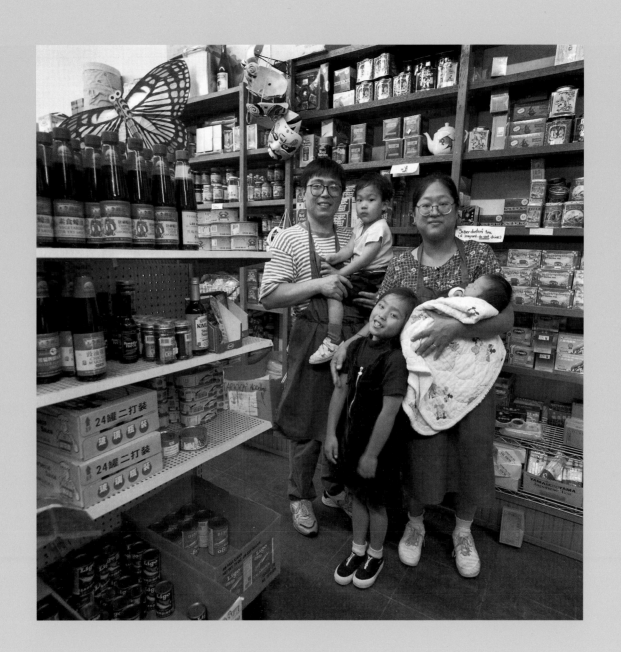

PHOTOGRAPHS BY

Joseph Allen

Thomas Arndt

Stephen Dahl

Chris Faust

George Byron Griffiths

Terry Gydesen

David Heberlein

Wing Young Huie

Mark Jensen

Peter Latner

David Parker

Keri Pickett

Minnesota in Our Time

A PHOTOGRAPHIC PORTRAIT

EDITED BY GEORGE SLADE

 MINNESOTA HISTORICAL SOCIETY PRESS
St. Paul

CARVER COUNTY LIBRARY

This book is dedicated to Zoe Allen, Maren Dahl, Chad Faust, Juliet and Laura Slade, and all the other late-twentieth-century babies who will be reading these photographs fifty years from now.

The Minnesota Historical Society gratefully acknowledges John and Ruth Huss for their generous support of this publication.

Major funding for the MINNESOTA 2000 Documentary Photography Project was provided by Alfred and Ingrid Lenz Harrison. Additional support was provided by the Patrick and Aimee Butler Family Foundation and Robert J. and Sarah-Maud W. Sivertsen.

The 121 contemporary photographs in this book were commissioned by the Minnesota Historical Society for the MINNESOTA 2000 Documentary Photography Project. Between 1997 and 1999 these twelve photographers carried out projects of their own design depicting Minnesota in its transition to the twenty-first century. The result, a publicly accessible archive of 360 photographs, plus project notes and work prints, is held at the Minnesota History Center in St. Paul.

All photographs copyright © 2000 by the artists.

Manufactured in Canada

10 9 8 7 6 5 4 3 2 1

ISBN 0-87351-382-7 (cloth)
 0-87351-383-5 (paper)

♾ The paper used in this publication meets the minimum requirements of the American National Standard for Information Sciences—Permanence for Printed Library Materials, ANSI Z39.48-1984.

Front cover: David Heberlein, Wading pool, Beaver Creek Valley State Park, Caledonia, July 25, 1998
Back cover: Mark Jensen, Fang Keu and Sao X. Vang, truck farmers from Hugo, at the Minneapolis Farmers Market, August 1998

Library of Congress Cataloging-in-Publication Data

Minnesota in our time : a photographic portrait / edited by George Slade ; photographs by Joseph Allen . . . [et al.].
 p. cm.
ISBN 0-87351-382-7 (cloth : alk. paper)
ISBN 0-87351-383-5 (paper : alk. paper)
 1. Documentary photography—Minnesota. 2. Minnesota—Pictorial works.
 I. Slade, George, 1961–
 II. Allen, Joseph, 1964– III. Minnesota Historical Society.

TR820.5 .M495 2000
779'.99776—dc21 00-027091

Documentary photographs record information and portray people on both sides of the camera lens. On the opening pages of this book are glimpses of Minnesotans at each end of the twentieth century; together they form an overture to viewers to consider photography's complex role as a medium of historical representation.

Page ii: Photographer unknown, *Man standing in bedroom, possibly William North residence, 730 East Fourth Street, St. Paul, 1900;* Page iii: Thomas Arndt, *Two men, Lake Calhoun, Minneapolis, June 1999;* Page iv: Guy M. Baltuff, *Boy, 1900;* Page v: Peter Latner, *Teens on Main Street on a summer evening, Walker, June 30, 1998;* Page vi: Photographer unknown, *Mary Parker, White Earth, 1897;* Page vii: Terry Gydesen, *Ed and Doris Lundberg from Detroit Lakes by their trailer, Quartzsite, Arizona, January 1999;* Page viii: Brooks, *Farm scene in Morrison County, 1900;* Page ix: Mark Jensen, *John, holding Harry, Stephanie, and Katherine Park, holding Gabriell, First Oriental Grocery, Duluth, September 1998.*

CONTENTS

PREFACE

BONNIE G. WILSON

"HOW ARE YOU PREPARING FOR THE NEW MILLENNIUM?" That was a question asked by millions in the late 1990s, many expressing concern about computer technology or an Armageddon. But when posed to me in 1994 by a group of photographers and photo historians, the question meant, "What is the Minnesota Historical Society planning to mark this moment in time?" They challenged the Society—an institution charged with saving the past for the future—to create something meaningful, useful, and artful for posterity.

So a committee of representatives from the Society and the photography community formed to devise a project we soon began calling MINNESOTA 2000. The project would depict turn-of-the-century Minnesota and serve as a visual benchmark for the time. Documentary photography would be the medium. Our final "document": a multifaceted look at lives and landscapes in Minnesota, focusing on common experiences and sights in a diverse population of individuals. Capturing places and lifestyles that were endangered or disappearing at the end of this millennium was not our purpose.

Commissioning photography was a new tactic for the Minnesota Historical Society. Up to this time, the Society had collected images created within the various contexts of photography: amateur, commercial, journalistic, fine art. Now, instead of merely collecting what others chose to record, it dared to play a hand in deciding what should be recorded. And so the call for proposals went out: "Make History!"

Several goals were central to the project committee's planning. Most important, we wanted to show people, places, and activities that are overlooked or only occasionally documented by the media and commercial photographers. We wanted to do what documentary photographers do best—concentrate on specific subjects for an extended period of time to develop a deep understanding of those subjects and communicate that understanding to the viewer.

As a curator working with photo collections at the Minnesota Historical Society, I have found that scenes of everyday life made over the last century are the most

fascinating and revealing. People at home, neighborhood streets, the factory floor all are views that researchers request again and again. Some requests are difficult to fill. Photos of servants, hired girls, and even housewives at work are extremely rare, though housework took place in every home. Commercial photographers and photojournalists follow trends that pass over the common experience to focus on the unique or sensational. Consequently, the photographic record has gaps or leaves details underexposed. So the guiding question for this project became, "What can we show to give posterity a more complete picture of our people and our world?"

Second, we wanted to make the project results accessible to as many people as possible. The MINNESOTA 2000 photos, along with an archive of all materials generated during the course of the project, would find a permanent home at the Minnesota Historical Society, where not-for-profit researchers would be able to use them for any noncommercial purpose. In addition, thousands of viewers would see the results of the project in a photographic exhibit at the Minnesota History Center and in this book.

Third, it was important that the photographs be of the highest quality, made by the region's finest documentary photographers, who would draw on their considerable artistry to portray common people going about their daily lives.

The committee established a methodology for the project with advice from the photography community. In 1995 a group of fifty photographers gathered to discuss the project and review current documentary work. Then in 1997, and again in 1998, a call for proposals went out to documentary photographers throughout the region. Panels of curators, photographers, and historians reviewed nearly 100 proposals. Finally, twelve proposals were selected based on the quality of the work shown and the appropriateness of the proposed subject to the project's goals.

Because the work was commissioned, the photographers were subject to direction by the project director, project advisors, and a subject specialist assigned to each topic. But no one sent the photographers out with lists of desired images. Each had a great deal of freedom to choose the specific locations and people to be photographed.

Most photographers found that their original proposal underwent changes during the course of the project. Peter Latner intended to photograph six main streets in depth; he created instead a composite view of the small-town landscape from images of twenty-six towns. David Heberlein proposed to show tourists experiencing state parks in a point-and-shoot frame of mind, as tourists with cameras in hand often do in national parks. He found instead the common state park visitor to be a Minnesotan who returned many times to the same spot to enjoy the natural resources there. Wing Young Huie wanted to show the lives of recent immigrants in rural Minnesota but discovered that "recent" didn't describe all cases. Some of the Hispanic and Laotian people in his pictures had lived in rural Minnesota for more than a decade.

Some shifts in course were the result of input from the subject specialists. David Brennan, advisor to Mark Jensen, encouraged the photographer to seek out businesses in all stages of development, from long-standing to mid-development to start-up. Gerald Bloedow, advising Terry Gydesen, observed that active retired seniors enjoy relatively good health, a strong connection to family, and lots of time for socializing and volunteering. He cautioned her against depicting her subjects as "greedy geezers." A teenager, Anne Preller, guided Keri Pickett through the thicket of teen life, showing her what was typical of teens today. Peter Rachleff influenced the final selection of David Parker's photos by stressing the importance of choosing worker portraits in addition to work-process photos—an approach that makes the worker central to the world of work, not just a cog in the wheel of production.

The results of the MINNESOTA 2000 project are as rich and artful as we had hoped. At the end of this project, the Society owns 360 fine art photographs to exhibit and to preserve as a resource for public research. In addition, the project archive contains extended interviews with the twelve photographers, detailing the experiences they had in creating each photo. The archive also includes work prints of all other scenes the photographers recorded, printed materials acquired in the course of each shoot, and notes from all meetings. The complete project archive is available for study in the Minnesota History Center Library.

This project is indeed well placed at the Society, which collects both historical and fine art photography. Since the Civil War era when it acquired its first photo, the Minnesota Historical Society has been the repository for all types of portrait, scenic, and event photography. From daguerreotypes to digital images, the collection contains the visual history of the state created by commercial photographers, amateur photographers, and photojournalists. In 1981 the Society began collecting fine art photography to represent the work of Minnesota artists who chose photography as their medium. The MINNESOTA 2000 project adds immeasurably to both aspects of the collection, contributing works with high artistic content created to serve as historical documents.

The Minnesota Historical Society is indebted not only to the photographers whose work is included here but also to the many companies, families, and individuals who allowed the photographers to spend time with them. All are now a part of Minnesota's historical record.

Minnesota in Our Time

INTRODUCTION

ROBERT SILBERMAN AND GEORGE SLADE

"DOCUMENTARY PHOTOGRAPHY," wrote Dorothea Lange in 1940, "records the social scene of our time. It mirrors the present and documents for the future. . . . It is preeminently suited to build a record of change."[1]

That statement by Lange headed the invitation sent by the Minnesota Historical Society to photographers soliciting proposals for the MINNESOTA 2000 Documentary Photography Project. From the first planning meetings to the final selection of prints, the project took up Lange's charge: to address both present and future with that special double vision required of all photography that seeks to establish "a record of change."

Lange spoke from deep personal experience. A member of the team that photographed for the Farm Security Administration (FSA) during the 1930s, she took a photograph that became one of the best-known of all American images—a migrant mother and her children at the depths of the Great Depression. That picture is now one of more than 150,000 photographs in the FSA collection at the Library of Congress. The portrait of Depression-era America captured by that photographic project shapes our sense of those hard times. And as the most famous group documentary effort in the history of photography, one devoted to the creation of a visual archive, the FSA continues to inspire efforts such as this one.[2]

Because the MINNESOTA 2000 project was sponsored by the Society, an institution whose mission is to collect, preserve, and interpret Minnesota history, the project assumed, from the start, a commitment to documentary photography as an instrument of historical understanding. That meant trying to determine what visual images of our time might prove most valuable to future generations and in particular trying to illustrate the changes taking place.

There were precedents for such documentary activity in Minnesota. FSA photographers Russell Lee, Arnold Rothstein, Jack Delano, and John Vachon photographed in the state.[3] But Minnesota has its own rich tradition of documentary photography,

3

epitomized by the achievement of Jerome Liebling, longtime faculty member at the University of Minnesota, whose influence as photographer, teacher, and role model cannot be overstated. During his years in Minnesota, from 1949 to 1969, Liebling compiled an extraordinary record of a pivotal era. In Liebling's humanistic approach to social documentary photography, the portrait is central, and he brought his sharp yet compassionate vision to politicians at the State Capitol as well as workers in the canneries of Le Sueur, residents of a St. Paul home for the blind, and down-and-out inhabitants of Minneapolis's Gateway district.

Many other individual photographers have engaged in documentary projects in Minnesota, notably John Szarkowski in *The Face of Minnesota*, published in 1958 to commemorate the one hundredth anniversary of statehood. There also have been group projects such as the one that recorded the state of the state for the nation's bicentennial in 1976, and others connected to academic programs that documented life on the Iron Range, in communities around Moorhead, and, beginning with Liebling's classes at the U of M, in the Twin Cities.[4] But no individual or group project has had the scope, ambition, and scale of MINNESOTA 2000.

With a dozen photographers working in a dozen different styles on a dozen different subjects, MINNESOTA 2000 aimed at generating a grand total of 360 images, thirty per photographer. Obviously, in a land containing millions of people, thousands of lakes, and hundreds of towns, a dozen photographers could not photograph everything. If not everything could be recorded, then what should be? The original call for proposals stressed the need to deal with subjects not normally represented in a sustained way by the mass media. That deliberately ruled out celebrities and major news events. Possible topics were suggested but it was up to the photographers to make concrete proposals.

Throughout the project, discussions were filled with considerations of coverage and balance. Was the project doing justice to a variety of age groups? Income levels? Ethnic and racial groups? Areas of the state? In the end, some major areas of contemporary Minnesota life played a minor role. There are photographs of religion and agriculture, for example, though they appear in projects devoted primarily to other subjects. Omissions were inevitable. What the photographs taken for the project do demonstrate is the power of selection, when driven by the intense personal engagement of the photographers with their subjects and executed with intelligence and skill.

The coverage of senior citizens demonstrates how subjects evolved in the course of the MINNESOTA 2000 project. The original planning committee believed there was a need for a project, or even two, covering the lives of senior citizens. Maybe, we thought, one photographer could record the lives of seniors living in a retirement residence while a second could photograph seniors still living independently or perhaps

with their children. Then Terry Gydesen came up with the most surprising and, in its own way, daring proposal of the entire project: to photograph Minnesota senior citizens outside Minnesota, in Sunbelt residences where they migrated each winter as "snowbirds." That opened up the possibility of photographing people both at home in Minnesota and in their seasonal homes-away-from-home. In the end, the project's look at seniors focused on life in the winter communities, as Terry accompanied her own parents on their annual trip to Florida and then explored the world of snowbird life there and in Arizona. In documentary projects, it often seems, the best-laid plans don't get dropped, they just get better.

Documentary projects are always about process—about photographing a subject and perhaps photographing it again, drawing up lists and revising them, exploring leads that don't pan out and new possibilities that suddenly appear. Always the discussions between photographers and project advisors returned to the all-important issue of change: What should be photographed to best represent the transformations now taking place in Minnesota? A tricky question, since any answer would necessarily be speculative. Fortunately, there were experts to help, in the form of subject specialists who counseled individual photographers in their particular area of expertise, providing ideas, contact names, and, perhaps most welcome, enthusiasm and a lively interest in each new batch of photographs.

When Szarkowski was working on *The Face of Minnesota* in the mid-1950s, he could not have known that Metropolitan Stadium, where he photographed a baseball game, and Memorial Stadium, where he shot the U of M Golden Gophers playing football, would not survive until the end of the century. But he did photograph new suburban housing developments and the Southdale Shopping Center, which he must have realized were but the first signs of dramatic changes just under way. And he noted pioneering efforts in the Minnesota electronics industry. Without being prophets or futurists, we knew that some subjects would be essential for any consideration of a changing Minnesota in the late 1990s: the explosive growth of high technology as an industry as well as a part of everyday life; the increased longevity and vitality of senior citizens; a very different social mix than existed even a short time ago. In Szarkowski's portrait the population is almost entirely white, except in photographs depicting Native American reservation life. There is, however, an emphasis on the customs associated with Norwegian Americans, Polish Americans, and other immigrant groups by then well settled. In contrast, MINNESOTA 2000 shows the strong presence of people of color—a phrase that would have been puzzling in the 1950s—in a number of projects, including Joseph Allen's portrait of urban Indian life, a study of a community made from within by one of its members.

The documentary tradition has often been identified with a liberal, even radical

political perspective, a sympathetic concern with social welfare that sometimes leads to exposé and advocacy. MINNESOTA 2000 had no overt political agenda, no particular spin it wished to apply to shape public opinion, no proposed legislation it wished to support. Some photographers undoubtedly revealed concerns that could appear political, but in each case—Wing Young Huie's photographs of minority populations in small towns, David Parker's blue-collar workers—the social phenomenon being recorded was deemed important as a contrast to the social scene in Minnesota only a few decades ago. If there was an agenda at work in this project, it was primarily a populist one—of trying to show just how extraordinary the lives of so-called ordinary people could be, and of making the photographs available to the public through the services of the Minnesota Historical Society.

Seen through the eyes of MINNESOTA 2000 photographers, the physical landscape, too, bears signs of social change, as David Heberlein demonstrates in his images of the state park system and Chris Faust shows in recording what has changed—and what hasn't—along the Minnesota River. Photographs that may show "timeless" Minnesota scenes are relatively few and are included more to establish a perspective on change visible in the other photographs than to present some eternal, unchanging essence of the state.

For some of the photographers in this project, trying to accommodate an idea, especially one as potentially overwhelming as "Minnesota now," proved difficult at first. A recurrent joke in project discussions: Put a calendar in each scene to make it appropriately historical, undeniably of the present. But not every picture had to make an explicit statement about change or a particular historical moment. And sometimes key information about a photograph came out only in a caption, as when we learn that a worker is a "temp," an important figure in today's workforce.

Sights that are so much a part of our lives as to be all but unnoticeable now become important historical markers. After all, a woman jogging in shorts would have been unheard of at the turn of the last century. And the Walkman she listens to in Thomas Arndt's photograph? That would have been pure science fiction, like the cell phone in another of his pictures. Straightforward, accurate observation of contemporary life always brings in a full load of historical signifiers, even if they become apparent only later, when clothing and hairstyles have changed along with so much else. The passage of time provides everyone with a kind of 3-D vision that makes some elements pop out of a picture because they are such vivid indicators of when the picture was made.

The thirty photographs commissioned from each photographer seemed both a dauntingly large number, given the project's time limitations and the photographers' standards, and a miniscule one, given the possibilities. Individual photos were never the primary focus of the project. It was always the ensemble, the totality, that mat-

tered: the overall portrait of small-town life, not the single town view; the general sense viewers would get of small-business owners, not insight into one particular proprietor. Of course there are strong individual photographs, and those photographs use their concreteness, their rendering of a subject in all its individuality, as a source of strength.

Some of the photographers had considerable experience as photojournalists and so were knowledgeable about how to get the shots that might be perfect for a photo story. In fact, some resisted repeating that formula, welcoming their MINNESOTA 2000 assignment because it freed them from the need to tell a story in just a few photographs. Huie insisted upon trusting his eyes, exploring the scene, finding the photos from within the situation rather than attempting to find a situation that illustrated some preconceived idea. This project granted Huie and others the luxury of following an individual point of view rather than a set of journalistic conventions.

But for all the variety and freedom this project afforded, the MINNESOTA 2000 photographers observed a basic rule of documentary photography: the subject is more important than the photographer. At times, that would mean jettisoning a particularly lovely picture of a less important subject for a less striking one of a more important subject. Yet there are many photos that reflect an individual photographer's characteristic approach to the camera and the world. A grab shot in 35mm by Keri Pickett, thrusting the viewer into the scene, cannot be confused with the carefully ordered, more distanced portraits of Mark Jensen, shot with his square-format camera. And neither resembles the tableaux of George Byron Griffiths, with their interplay between physical and psychological distance, between the desire to move in close for immediacy and the impulse to back off for a fuller sense of the scene. Faust's panoramic camera makes his work immediately recognizable; perhaps less apparent at first is the elaborate formal and thematic counterpoint in the images he contributed to the project, from light humor to classic pastoral to disturbing images of a landscape and a world transformed. Similarly, Peter Latner's body of work progressively reveals his sense of an eerie emptiness on many small-town main streets.

Dorothea Lange wrote that documentary photography and art are not opposed. She was right, as the MINNESOTA 2000 photographs so vividly demonstrate. In documentary photography, the art frequently conceals itself, in images that are artful but not "artsy." These photographs, beyond the excellent quality of the prints, beyond the compositional skill, beyond the sense of the moment or the place, have a kind of weight to them, a mark of the sustained concern shown by the photographers toward their subjects. Some are good-humored, such as Latner's instant classic of teenagers gathered on a street corner; there's no doubt about that picture as a record of a particular historical moment. Some are more sobering, as in pictures by Parker and Stephen

Dahl that reveal much about work in the low-tech and high-tech worlds. But there is an underlying seriousness in all the work, grounded in the conscientious efforts by the photographers to explore their topics thoroughly, then provide viewers with a compelling record of what they found. The MINNESOTA 2000 photographs may not represent "The Truth" but they have truthfulness.

According to the photographer Willard Van Dyke, Lange believed the true test of her photographs would come fifty years after they were taken.[5] Maybe the true test of the MINNESOTA 2000 photographs will come only decades from now, not because history will judge but because viewers will then be able to see more clearly the value of the photographs as a guide to history. As with Szarkowski's images, so with these. What may not stand out as remarkable today certainly will later, in dozens of elements small and large, from running shoes to computers to mobile homes, marking the photographs as "so nineties" to viewers in years to come. For now, however, in historical close-up, these photographs offer a view—twelve views—of the way Minnesota was changing as it turned the corner to a new millennium.

1. Dorothea Lange, "Documentary Photography," in *A Pageant of Photography 1940,* ed. Ansel Adams, exhibition catalog, Palace of Fine Arts, Golden Gate International Exposition (San Francisco: S.F. Bay Exposition Co., 1940).
2. On the FSA and documentary photography, see William Stott, *Documentary Expression and Thirties America* (New York: Oxford University Press, 1973; reprint, Chicago: University of Chicago Press, 1986). FSA photographs can be seen online at the Library of Congress Web site, http://lcweb2.loc.gov/pp/fsaquery.html. For a more recent group documentary project, see *Changing Chicago: A Photodocumentary Portrait* (Urbana and Chicago: University of Illinois Press, 1989).
3. See *Picturing Minnesota 1936–1943: Photographs from the Farm Security Administration,* ed. with text by Robert L. Reid (St. Paul: Minnesota Historical Society Press, 1989).
4. See Jerome Liebling, *Jerome Liebling: The Minnesota Photographs* (St. Paul: Minnesota Historical Society Press, 1997); John Szarkowski, *The Face of Minnesota* (Minneapolis: University of Minnesota Press, 1958); and the Prairie Documents Photographic Book Series, Moorhead State University, beginning in 1990 with *For Sale By Owner*.
5. Willard Van Dyke, "The Photographs of Dorothea Lange: A Critical Analysis," *Camera Craft 41,* no. 10 (October 1934): 461.

THE PHOTOGRAPHS

JOSEPH ALLEN

URBAN INDIANS

THE 29,000 AMERICAN INDIANS in the metropolitan area of Minneapolis and St. Paul comprise half of Minnesota's Indian population. Yet this community has been largely overlooked in the mainstream media, where casino gambling and tribal treaty rights claim the most attention. As a journalist and photographer, Joe Allen has made it his mission to portray urban Indians, presenting the everyday issues that characterize their lives.

Allen's photographs of individuals and activities reveal the interweaving of tradition and modernity in the Indian community. They also signal the important role of the American Indian Center in the lives of Twin Cities Indians. Away from reservations, urban Indians in the last half of the twentieth century formed organizations to represent their collective interests. The American Indian Movement, born in a Minneapolis storefront in the 1970s, was one such organization. Today, the American Indian Center on Franklin Avenue in south Minneapolis is a crucial focal point. *The Circle* newspaper, Allen's employer, is based there. Eric Keast shows his work in the center's Two Rivers Gallery. Yako Myers leads workshops there. Donovan Goodman sews powwow costumes for himself and his nephew, helping them maintain an important community ritual. And well-attended Bingo games keep the center lively. As Allen describes it, the American Indian Center is an anchor in "the struggle to maintain and develop a Native identity in a rapidly changing world."

Dancers and dolls, Shakopee Community Powwow, August 1998

Donovan Goodman and his nephew Dude, Shakopee Community Powwow, August 1999

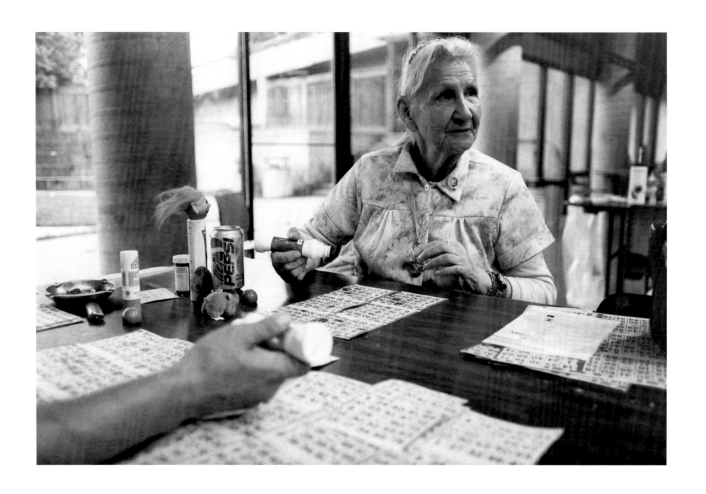

Mary Johnson's bingo night at the American Indian Center, Minneapolis, August 1999

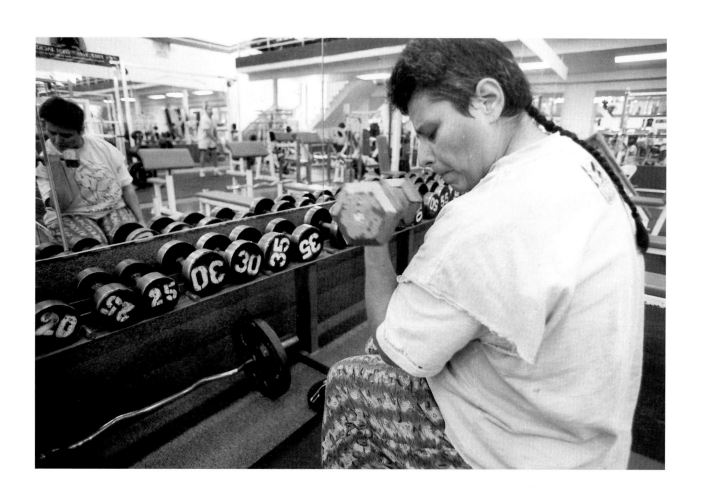

Yako Myers, competitive weight lifter, practicing at The Gym, Plymouth, January 1999

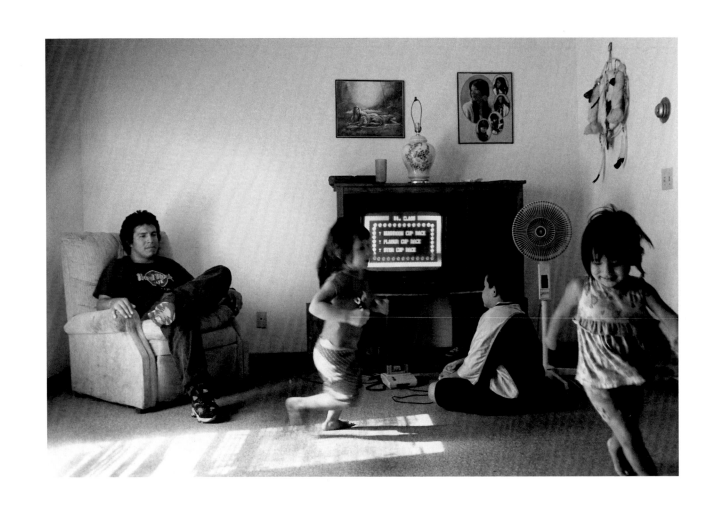

Frederick Matt family, Little Earth housing project, Minneapolis, July 1999

Terry Mousseaux making fry bread, Minneapolis, September 1998

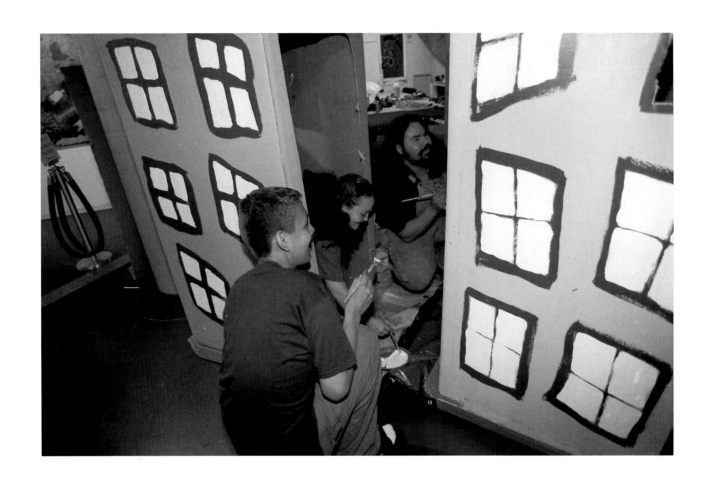

Eric Keast painting sets with youth from the Phillips neighborhood, American Indian Center, Minneapolis, August 1999

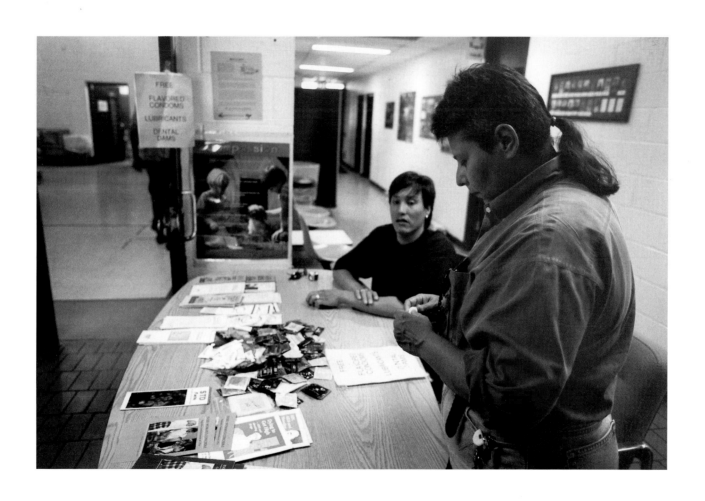

Yako Myers working at Pillsbury Neighborhood Services' Waite House, Minneapolis, August 1999

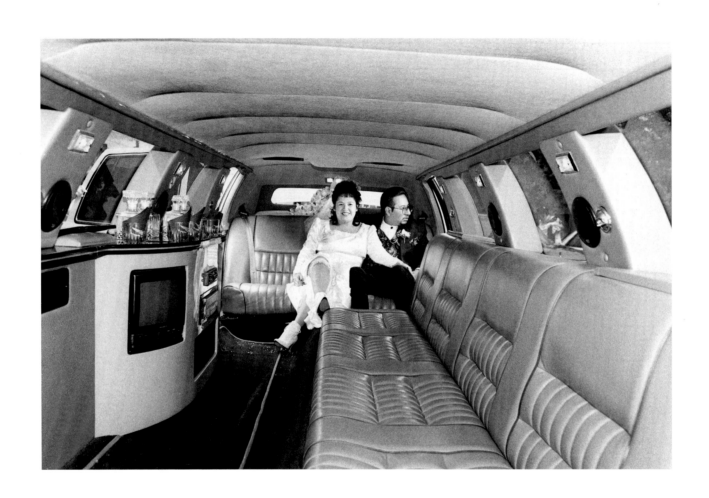

Donovan Goodman and Terry Mousseaux's wedding limo, Minneapolis, May 1998

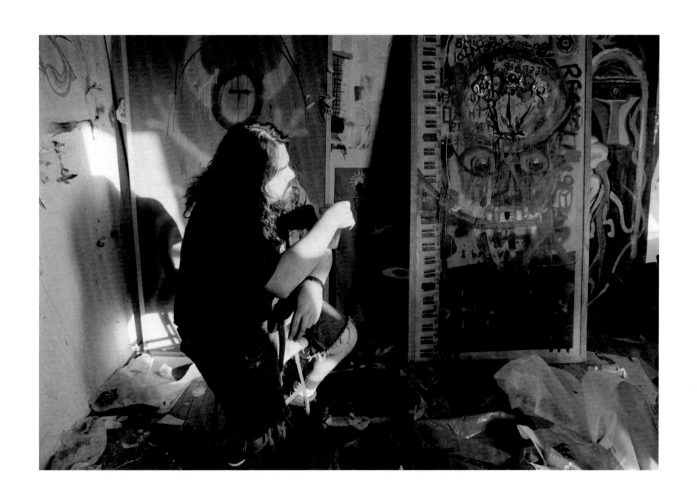

Eric Keast in his studio with his painting Y2K, Minneapolis, January 1999

THOMAS ARNDT

BY THE LAKES

LIFE IN THE "LAND OF SKY BLUE WATERS" is lived by the water's edge. Whether urban or rural, whether on, in, or beside the water, Minnesotans manifest a seasonless attraction to the state's liquid landscape. To Minnesota native Tom Arndt, water is the base element of the state's identity.

With an eye expert in recognizing spontaneous interactions between humans and their environments, Arndt creates images that delve into our lake-bound nature. Historically, the visual record of Minnesota's lakes has been either commercially produced scenic views or anecdotal family snapshots. Arndt's photographs deny neither tradition. These images possess certain timeless, pictorial qualities. But also present is a savvy sense of the evolving demographics of lake users; the waters exert a pull across all social and economic lines. Arndt's project is a civic portrait of lakeside Minnesota.

His modus operandi, in this project as in his work in general, does not rely on a shooting script. Arndt simply hangs out and closely observes the scene. Driving up from his home in Chicago for this project, he would identify certain lakes to visit during the course of a weekend, then mingle with the crowds, catch a ride from a boater, talk to the dog-walkers, or watch the preparations for a summer festival. Some pictures, like the Mille Lacs fishing scenes, required a degree of planning. But most of these photographs spring from Arndt's anticipation of the moments that capture Minnesotans' fascination with water.

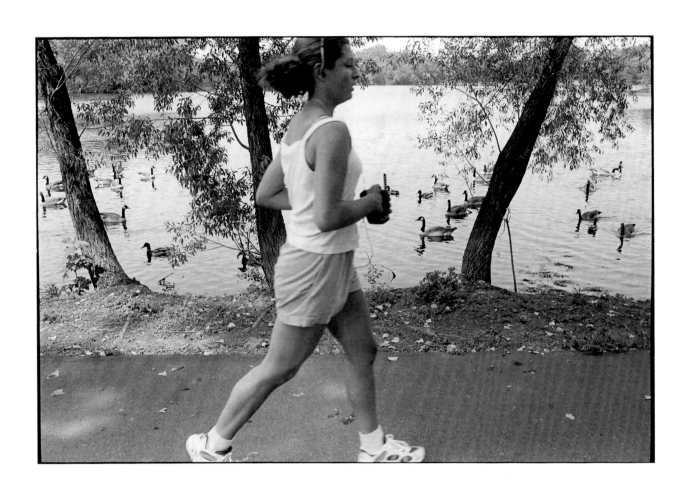

Jogging along Lake of the Isles, Minneapolis, June 1999

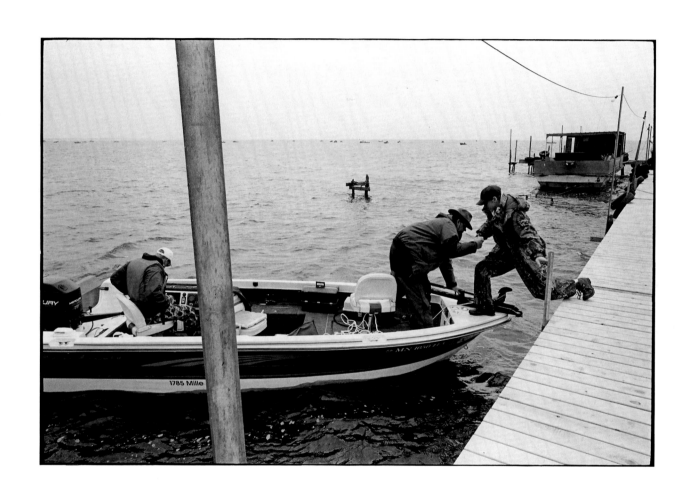

Fishing season opener, Mille Lacs Lake, Garrison, May 1999

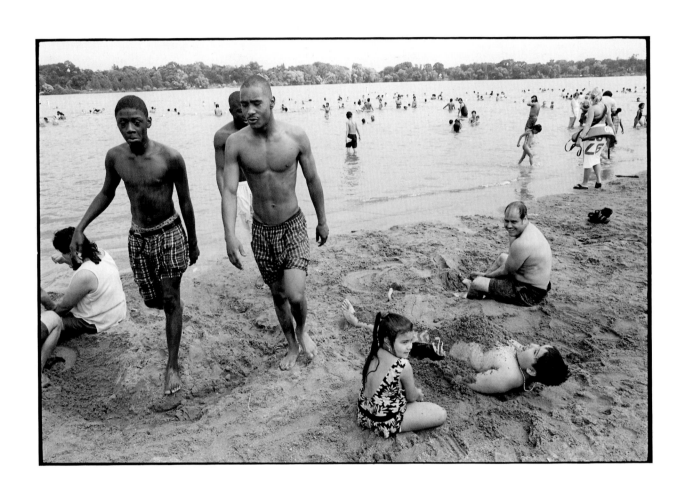

Beach life, Lake Nokomis, Minneapolis, June 1999

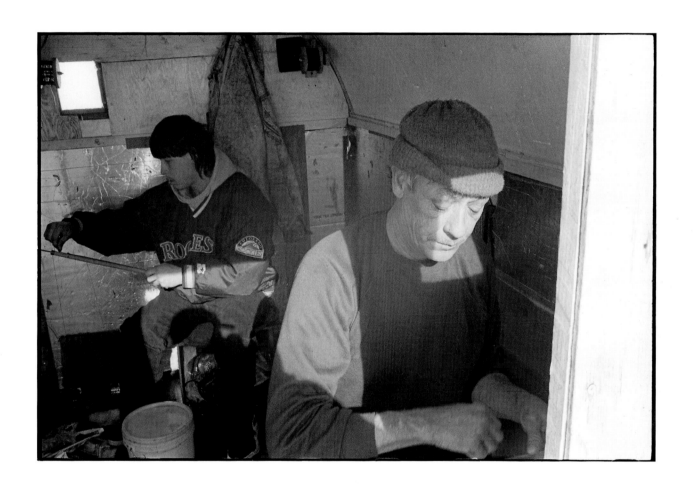

Father and son in an ice-fishing house on Mille Lacs Lake, February 1999

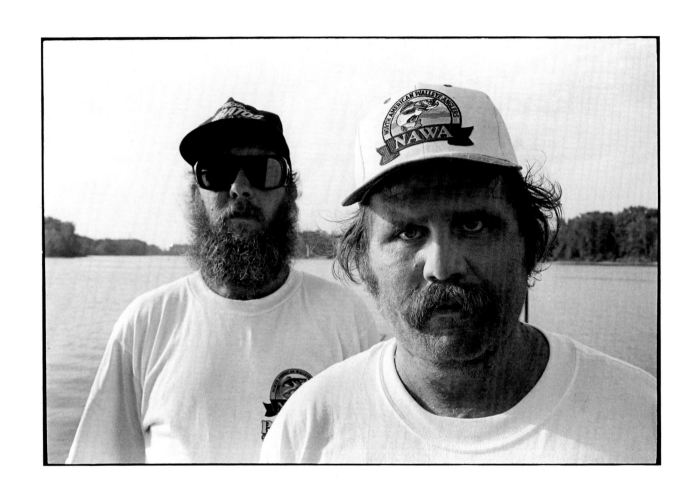

28

Fishing contest workers, Red Wing, September 1998

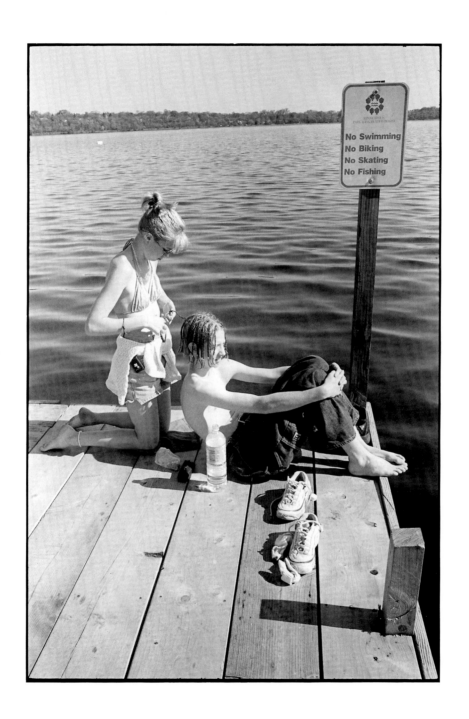

Teenage couple at Lake Harriet, Minneapolis, May 1999

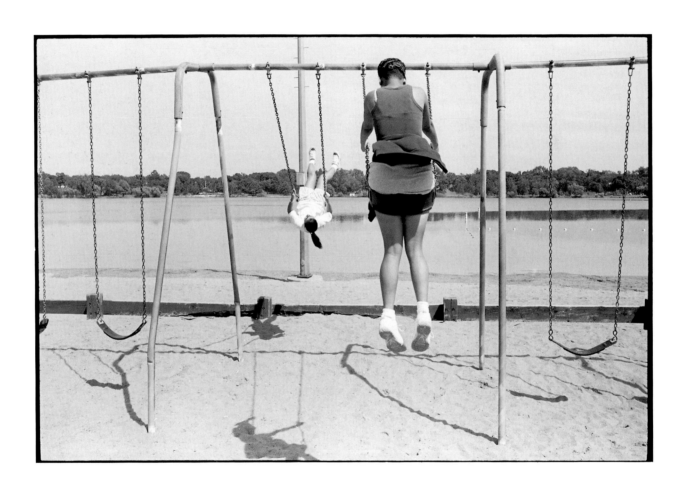

Girls on swing by Lake Nokomis, Minneapolis, June 1999

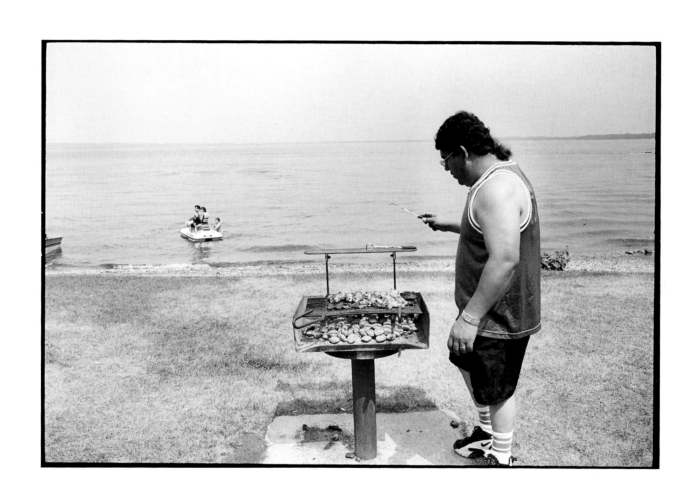

Barbecue on the beach, Green Lake, Spicer, July 1998

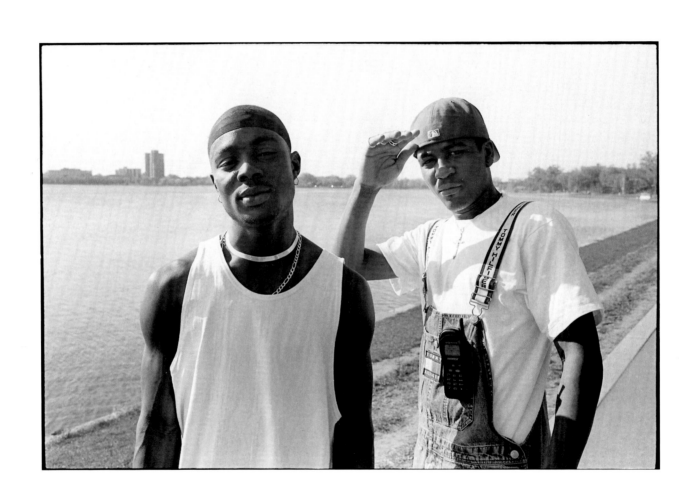

Two men, Lake Calhoun, Minneapolis, June 1999

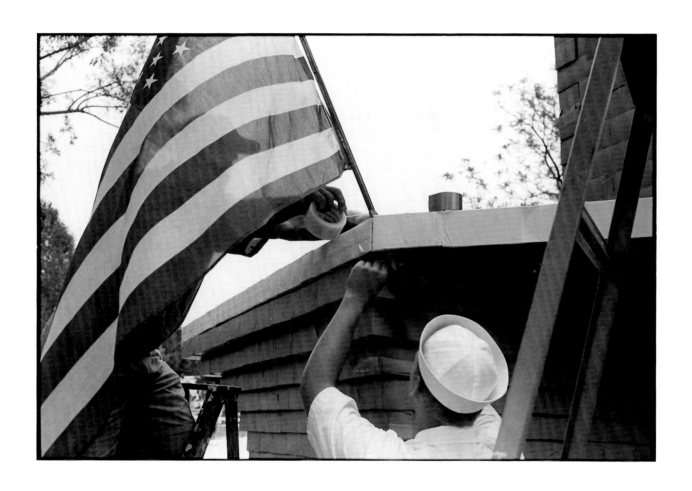

Preparing for Aquatennial milk-carton boat race, Lake Nokomis, Minneapolis, July 1999

STEPHEN DAHL
TELECOMMUNICATIONS WORKERS

STEPHEN DAHL HAS ESTABLISHED HIMSELF as a recorder of the human face of complex industries that, though they serve some of our most common needs and desires, function outside our everyday awareness. For this project, he concentrated his efforts on the telecommunications industry, a faceless yet enormously influential force in our turn-of-the-millennium lives.

Dahl's work encompasses both the large themes of telecommunications and the individuals who carry out the nitty-gritty of the information age. He is a photographer whose documentary inclinations to inform blend with a deep concern for everyday lives. His hybrid approach combines the objective and the personal in a kind of candid environmental portraiture. To documentary's topical narrative, these images add a concise characterization of individuals—and, along the way, evoke such abstract qualities as perseverance, stoicism, and spirit. In viewing the telecommunications industry, Dahl aims not to explain or analyze but to humanize.

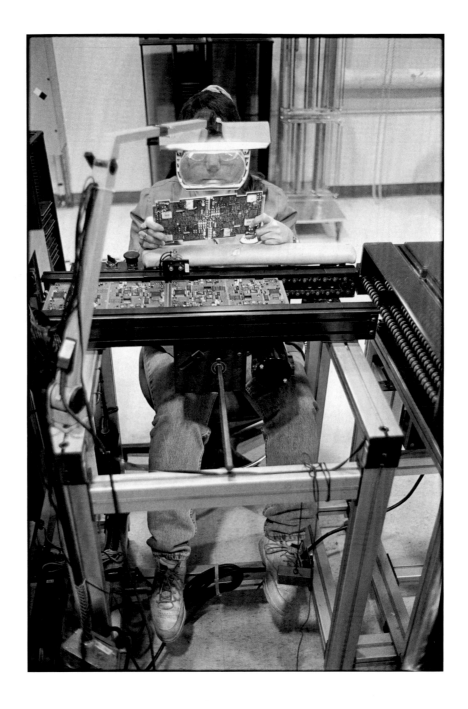

Circuit-board inspection worker behind a magnifying glass, ADC Telecommunications, Minnetonka, August 1998

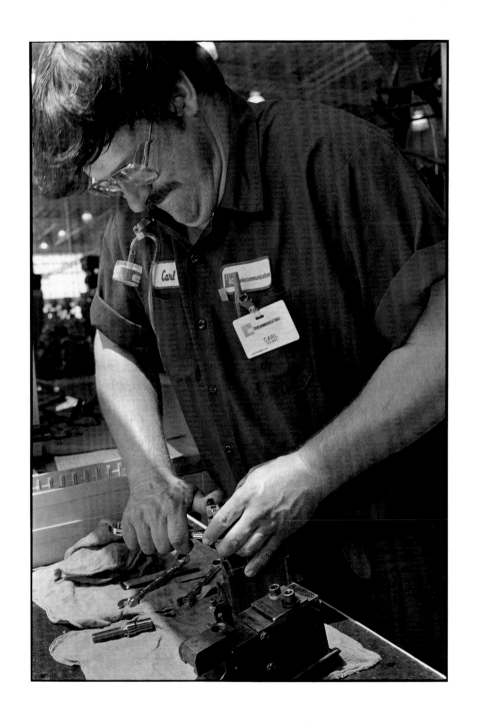

Carl Holmes, machinist for ADC Telecommunications, Shakopee, July 1998

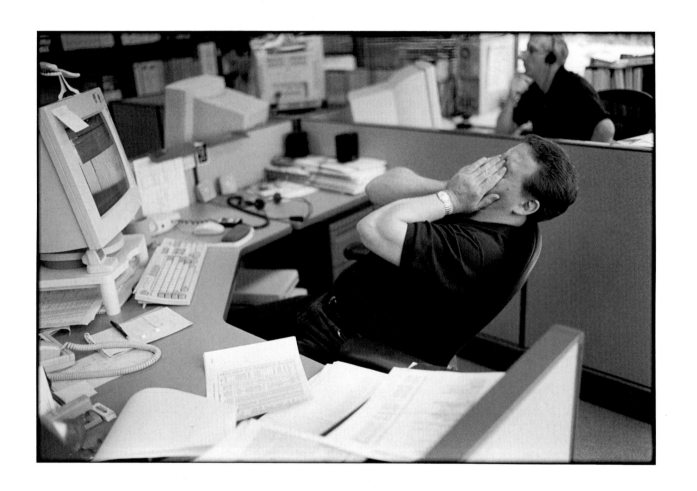

Man in cube, Norstan Customer Service, Maple Grove, July 1998

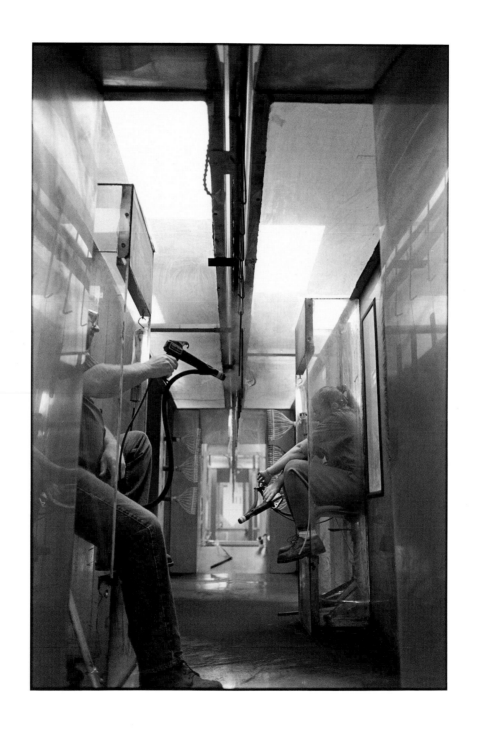

Pause in a paint booth, ADC Telecommunications, Shakopee, July 1998

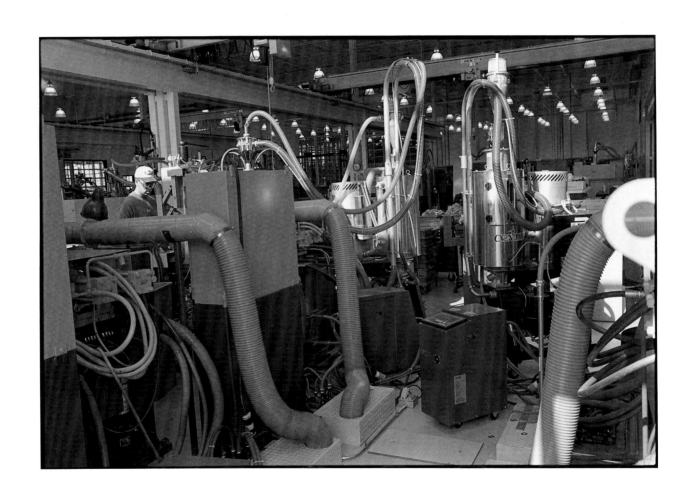

Plastic-injection-molding machinery, ADC Telecommunications, Shakopee, July 1998

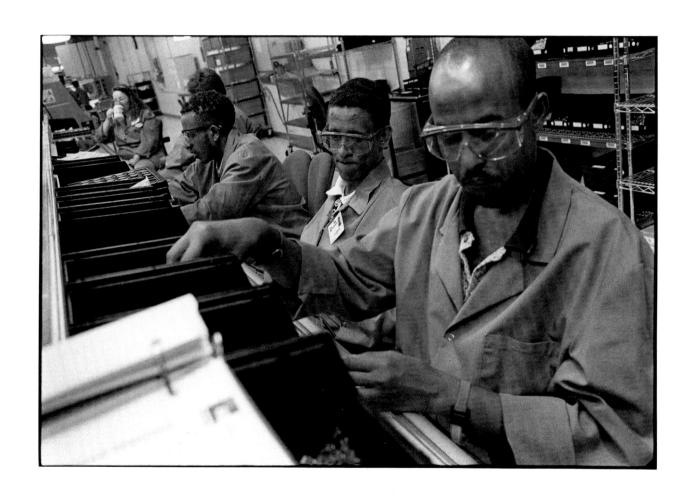

Circuit-board assembly line, ADC Telecommunications, Minnetonka, August 1998

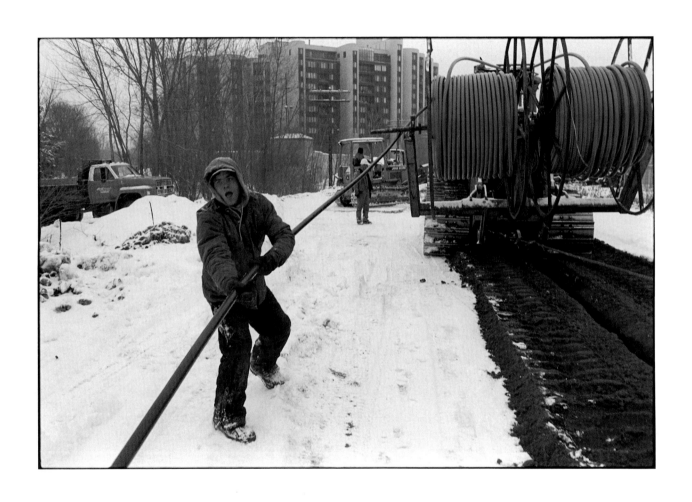

Pulling fiber optics cable, Spalj Construction Co. installation crew, Minneapolis, January 1999

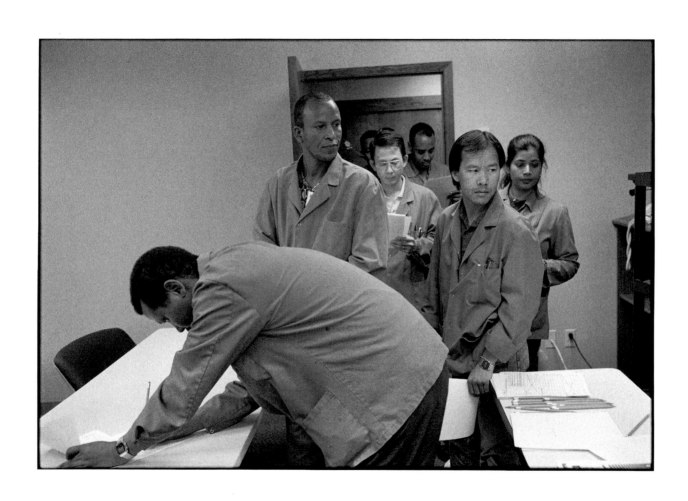

Temporary employees testing for permanent work eligibility, ADC Telecommunications, Hopkins, September 1998

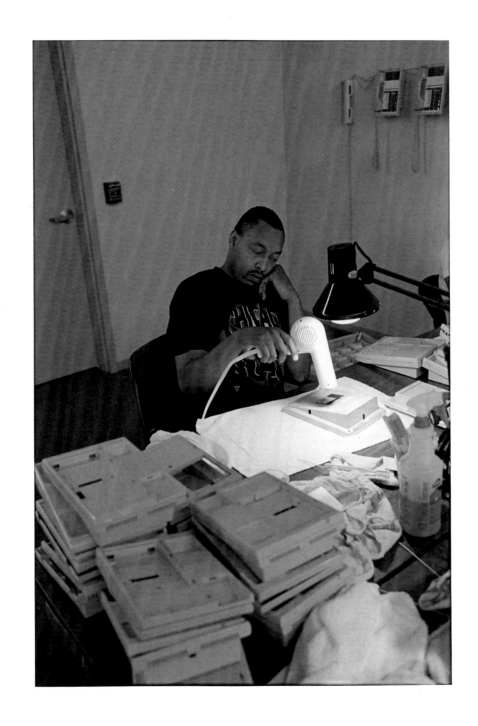

Hair dryer, Rolm Resale Systems, a division of Norstan, Maple Grove, July 1998

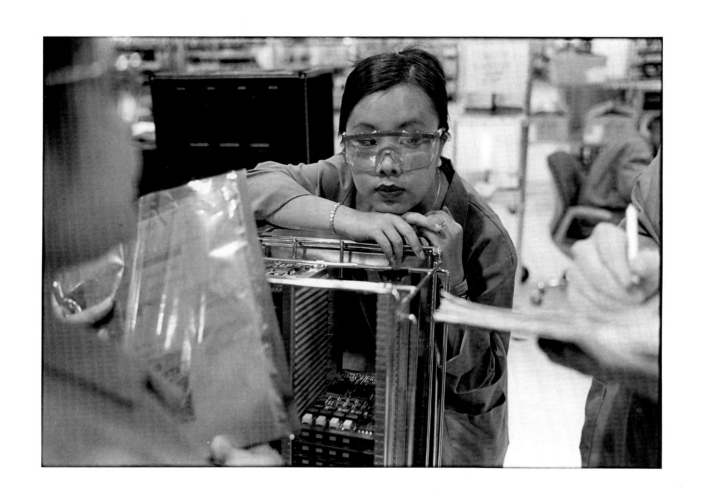

Woman leaning on hand, ADC Telecommunications, Hopkins, July 1998

CHRIS FAUST

ALONG THE MINNESOTA RIVER

RUNNING ITS COURSE ENTIRELY WITHIN STATE BORDERS, the Minnesota River can be seen as the state in microcosm. Chris Faust's photographs present the river as a natural stage for a host of human undertakings from small to extraordinary. He records river-related activities that span a continuum from the low-impact pursuits of fishing and camping to exploitation of the river's waterpower.

The prevalence of overland truck shipping and highway construction that Faust encountered suggest a certain amnesia in Minnesotans today about the river's presence. In a place like Bloomington, looking out from the Mall of America across overlapping rivers of concrete, it is easy to forget the proximity of the water. Yet in a place like the meeting of the Minnesota and Redwood rivers, near Redwood Falls, it is easy to imagine the river in its pristine, pre-settlement state.

This contrast of historic and contemporary faces of the river is especially poignant in two images—the river-level view of a Highway 55 overpass and the continuing struggle against eroding riverbanks in Carver. By vicariously placing our feet on parkland beneath the highway and forcing us to imagine thousands of drivers rushing past overhead, Faust illuminates the hidden yet essential nature of the river landscape. In Carver a project necessary to protect the town from a changing river expresses the people's desire to retain and protect their historic connection to the waterway.

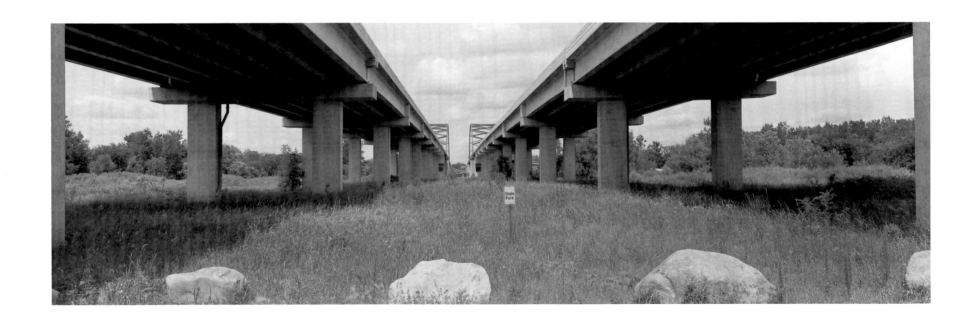

Cedar Avenue Bridge over the Minnesota River, Burnsville, August 1997

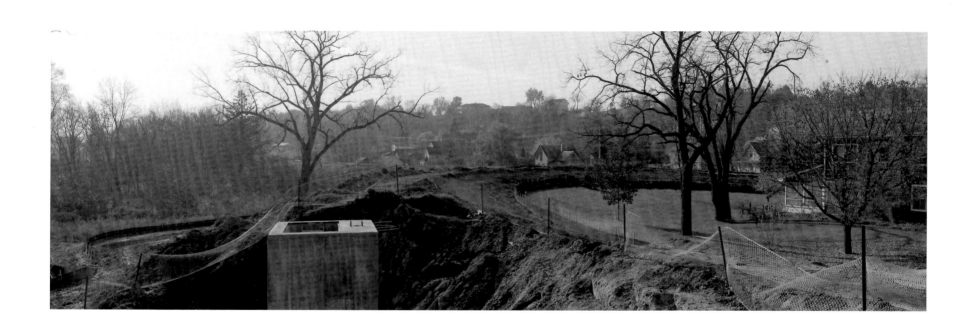

Constructing a new dike near the old Carver riverboat landing, October 1998

Cold Spring Granite Company quarry near Ortonville, September 1997

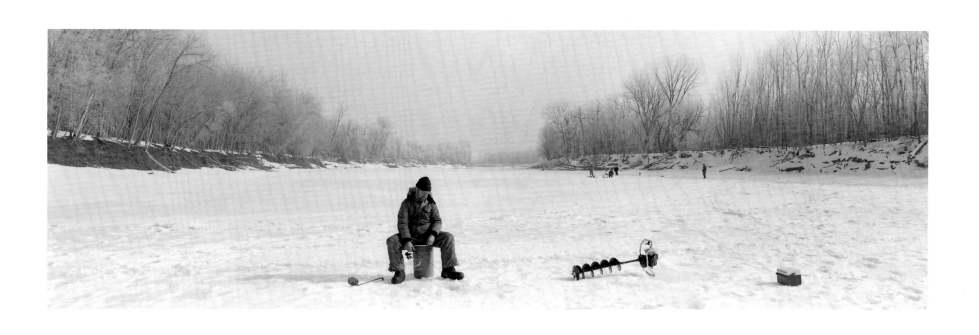

Doug Knute fishing on the Minnesota River off Highway 25 near Belle Plaine, February 1998

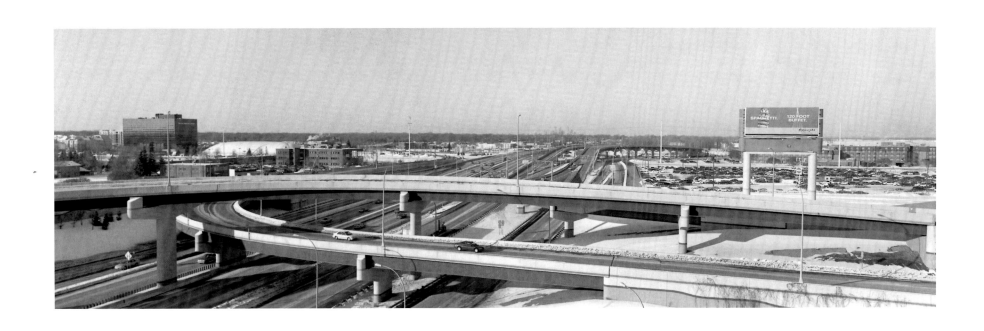

Freeway ramps leading to the Mall of America off Killebrew Drive, Bloomington, February 1999

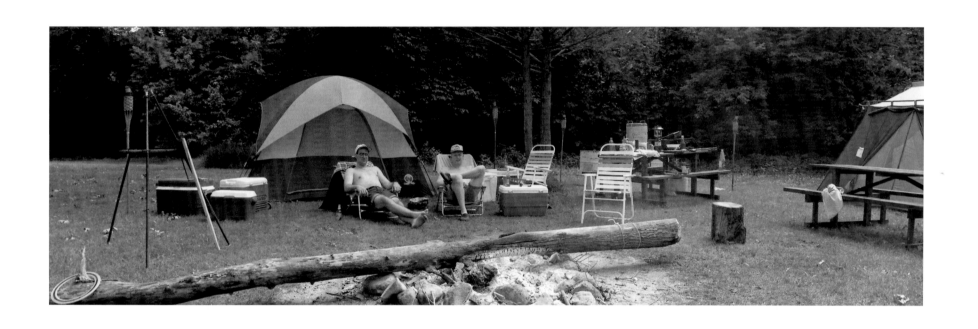

Campers Josh and Jay in a Renville County park near Morton, June 1998

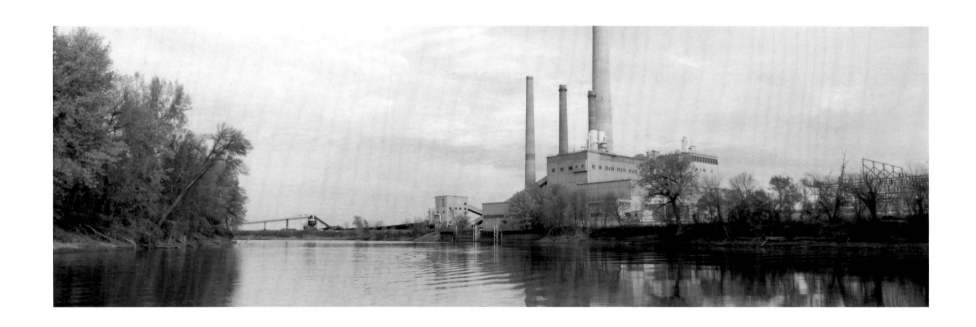

Black Dog Generating Plant, Burnsville, November 1997

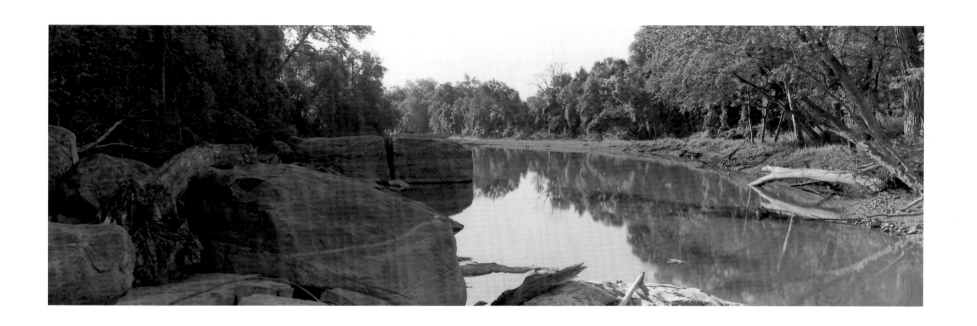

Conjunction of Redwood and Minnesota rivers near Redwood Falls, September 1997

Migrant workers fishing at State Highway 40, near Milan, September 1997

D & A Truck Line, New Ulm, June 1998

GEORGE BYRON GRIFFITHS
RAISING AND EDUCATING CHILDREN

GEORGE BYRON GRIFFITHS SET HIMSELF AN ENORMOUS TASK in attempting to record the raising and educating of children at the turn of the millennium. The scale of his chosen assignment, and his commitment to it, are apparent in the fact that he photographed at more than sixty locations during the course of the project. Because his finished portfolio would include only thirty prints, Griffiths knew that the critical work of preparing children for our complex, changing world could only begin to be represented here.

In an age when parents are encouraged to play Mozart for their offspring still in utero, it is no surprise that Griffiths encountered overwhelming evidence of caregivers' engagement in children's lives. Each of his images spotlights an every-day moment, from back-to-school shopping to learning the family business to dining out with grandparents. Though parenting philosophies and practices may differ in the subjective endeavor of raising children, Griffiths's photographs distill all child-rearing scenarios to their defining element—a relationship, carefully attended to and nurtured. In this way, a small group of photographs can effectively represent a universe.

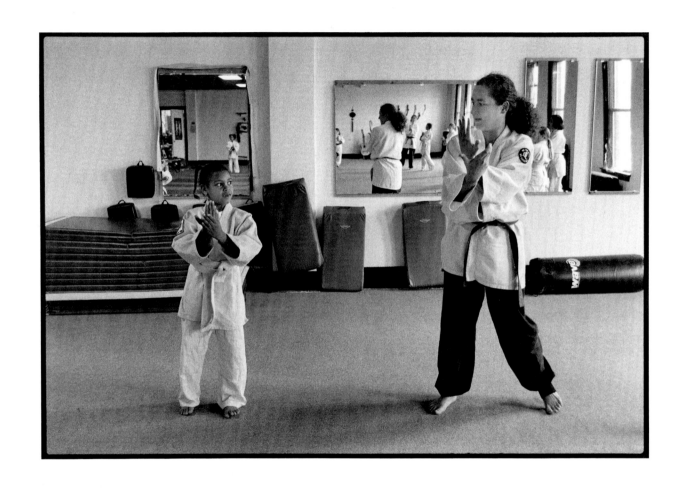

Latesa Sykes with martial-arts instructor Susan Budde, Minneapolis, April 17, 1999

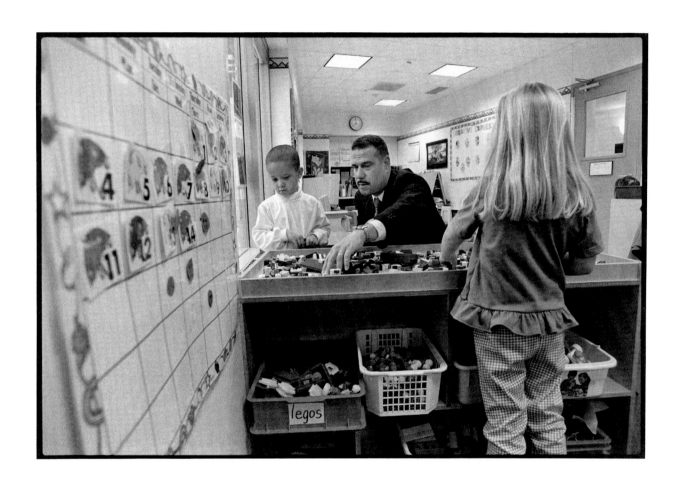

Troy Williams with Troy, Jr., before work, St. Paul Companies Children's Center, St. Paul, April 15, 1999

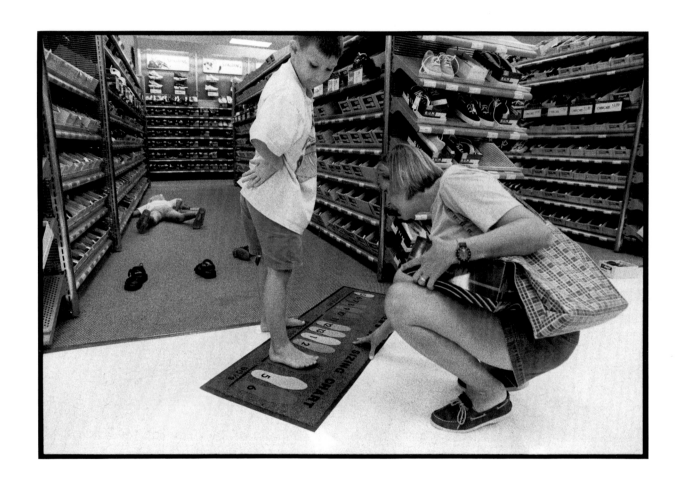

Vicki Robinson, her son Peter, and daughter Maggi shopping for shoes at Target Greatland, Edina, August 27, 1998

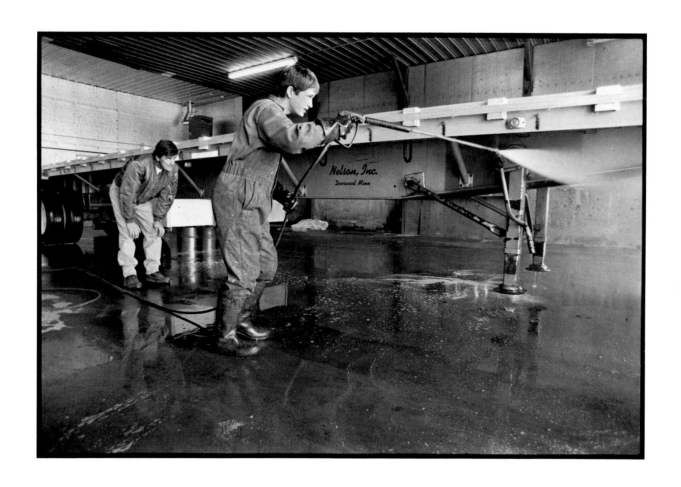

Tony Nelson watching his fourteen-year-old son, Joe, wash a semitrailer, Deerwood, March 26, 1999

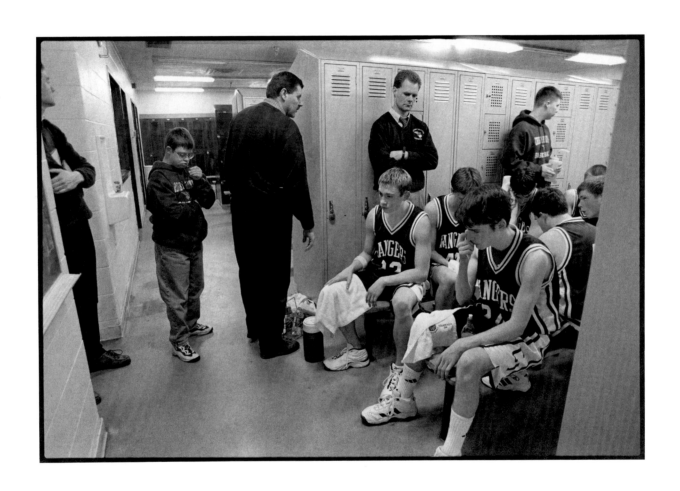

Coach Dave Galovich talking to his Crosby-Ironton team during halftime of a game against Greenway-of-Coleraine, Crosby, January 26, 1999

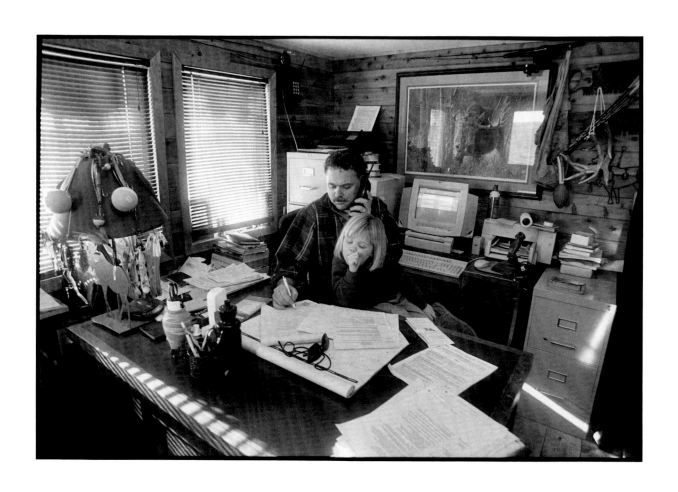

Jay Parmeter working with daughter Zoe on his lap, Crosby, December 14, 1998

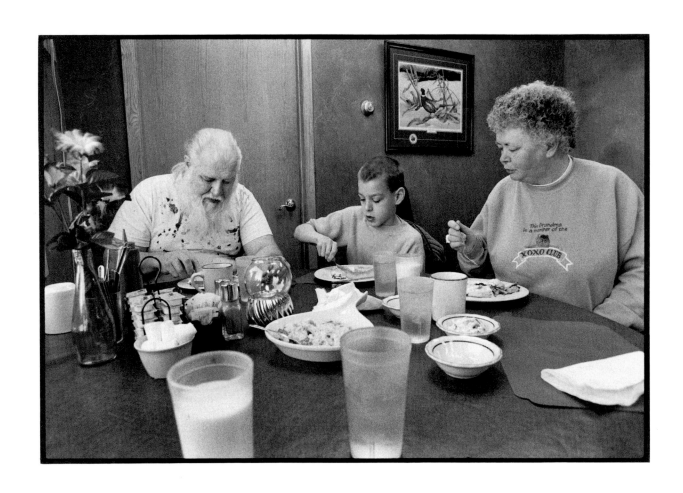

Patrick and Sharon Pierce, full-time parents to grandson David Simmonds, Crosby, March 7, 1999

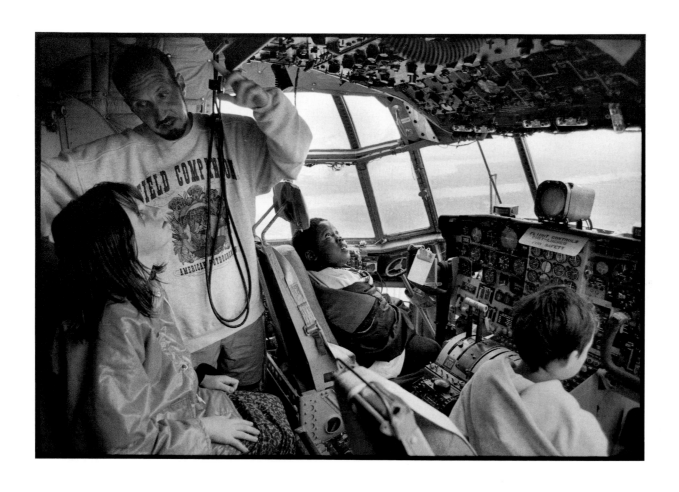

Starbase Minnesota instructor Mike Niemi with students Katie Blossom, Michael Spann, and Ding Thao,
Air National Guard Base, St. Paul, May 12, 1999

Becky Raskind playing with her "Barbie Magic Hair Styler," Edina, February 17, 1999

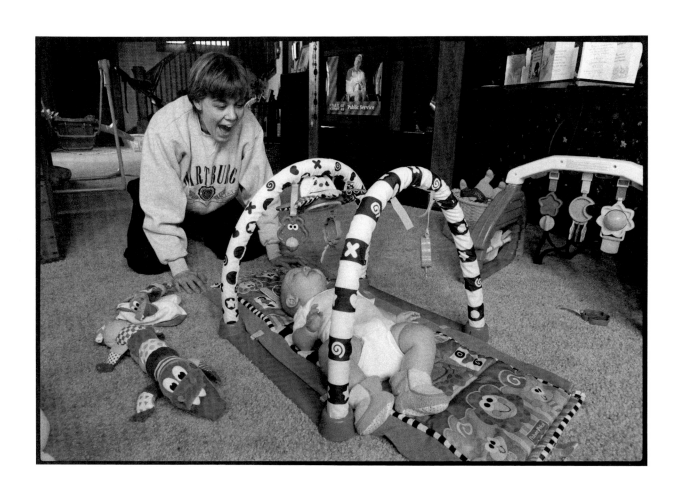

Pam Stock, a teacher on maternity leave, with her daughter, Sydney, Brainerd, April 8, 1999

TERRY GYDESEN

SNOWBIRDS

THE OPTION EXERCISED BY MINNESOTA SNOWBIRDS to decamp during the frigid winter months is an alluring one, as Terry Gydesen discovered. Her plan was to accompany her parents on their yearly southern migration, then go west to connect with other snowbirds in Arizona. But before long Gydesen evolved from observer to participant. After setting up camp in "Bluebird," her Volkswagen pop-top microbus, Gydesen realized the drawing power of a place in the sun. She now makes her own annual winter journey to Arizona.

Experiencing its climatological advantages led Gydesen to appreciate La Hacienda RV Park in Apache Junction, a Phoenix suburb. "Going native" improved her ability to make insightful photographs about the lives of snowbirds there. This personal stake also saved the project from becoming a gerontological study and pushed it beyond the sharp-edged, ironic documentation that characterizes the political campaign photos she has pursued since the late 1980s.

Snowbirds—typically people of a certain age who are retired from careers and no longer have children at home or other year-round obligations—swell the populations of various southern and southwestern towns during the winter months. Gydesen's photographs record several snowbird nesting arrangements, including "park"-model manufactured houses, towed trailers, and bus-like RVs. Viewing the seniors in a range of everyday situations, Gydesen discovered that a great deal of Minnesotaness is simply transported south to these migratory communities, with occasional mutations like the Oof-Da taco, made with Indian fry bread, not lefse.

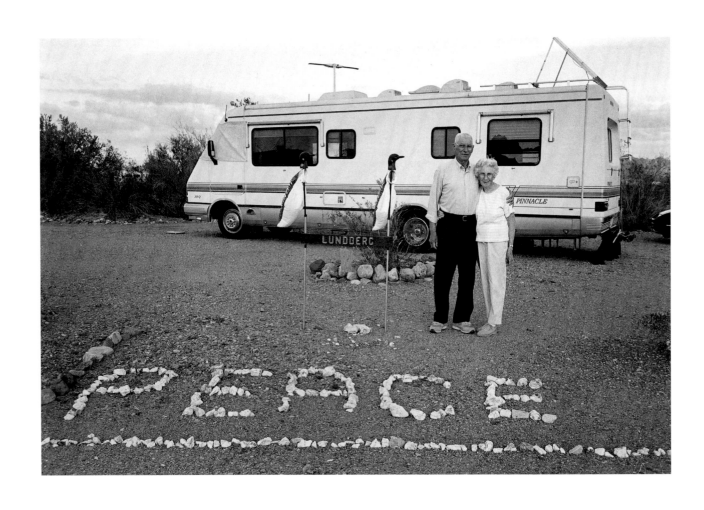

Ed and Doris Lundberg from Detroit Lakes by their trailer, Quartzsite, Arizona, January 1999

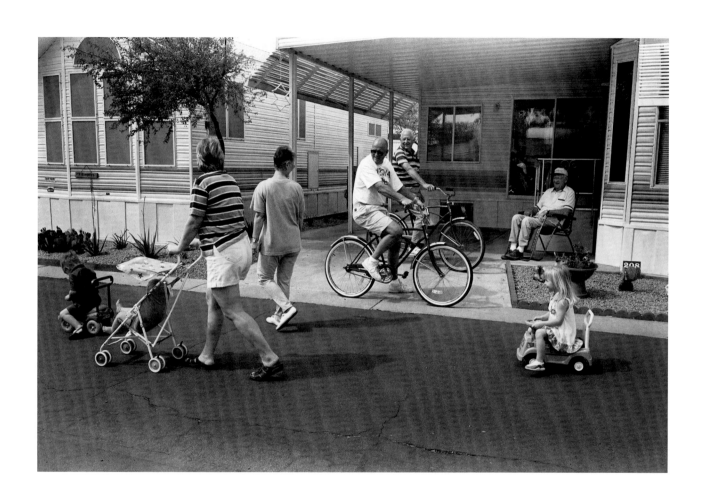

Walking with grandchildren, La Hacienda RV Park, Apache Junction, Arizona, March 1999

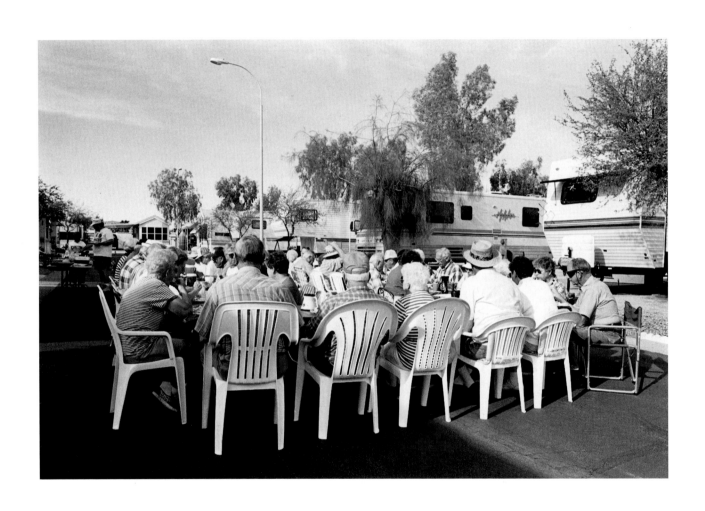

Street party potluck dinner, La Hacienda RV Park, Apache Junction, Arizona, March 1998

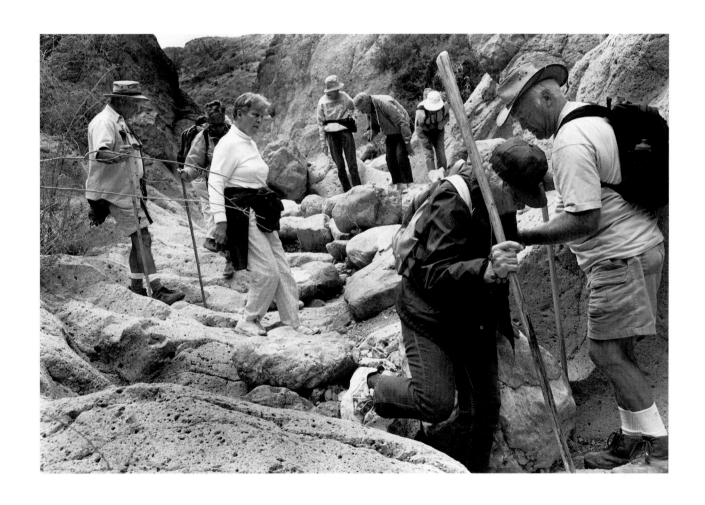

Hiking group from La Hacienda RV Park, Apache Junction, Arizona, March 1999

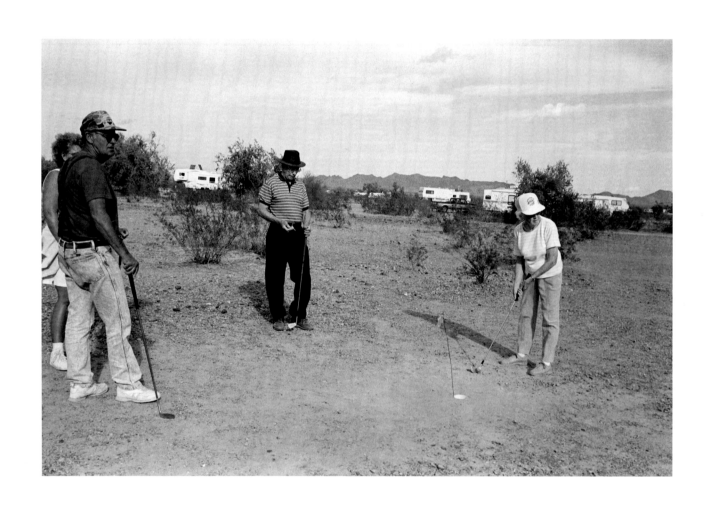

The Lundbergs playing golf, Quartzsite, Arizona, January 1999

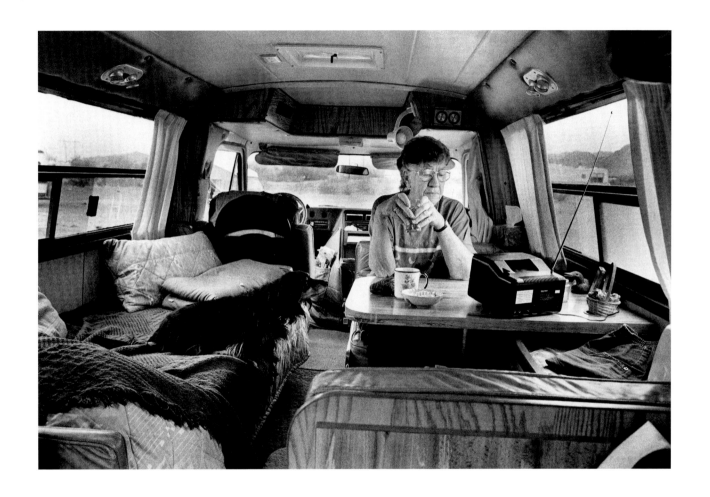

Shirley (Bird) Christianson from Bemidji with her dachshund, Sweetie, Quartzsite, Arizona, January 1999

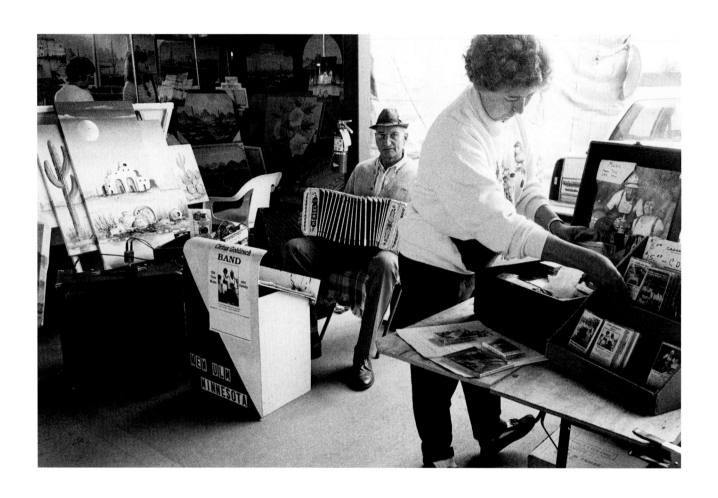

Cletus Goblirsch of New Ulm playing and selling music at a flea market, Mesa, Arizona, March 1997

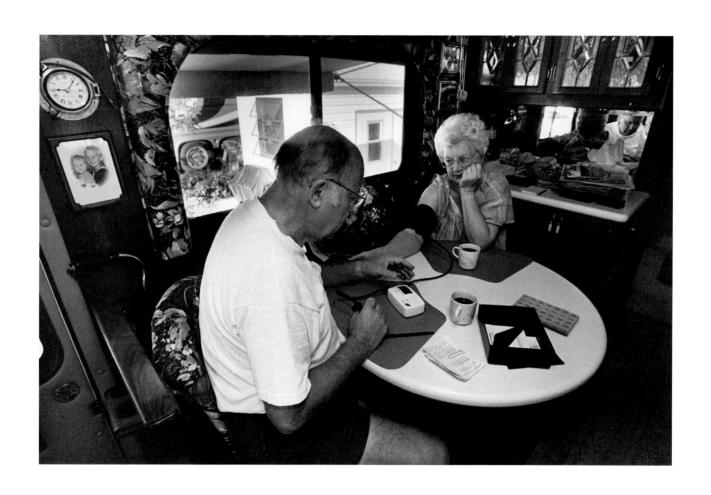

Lou Gydesen of Inver Grove Heights checking his wife Darlene's blood pressure, Naples, Florida, December 1997

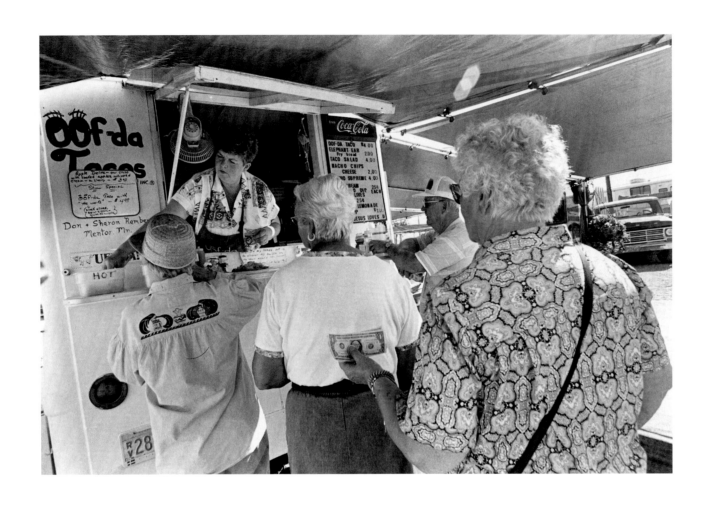

Sharon Ramberg from Mentor selling Oof-Da Tacos, Quartzsite, Arizona, February 1998

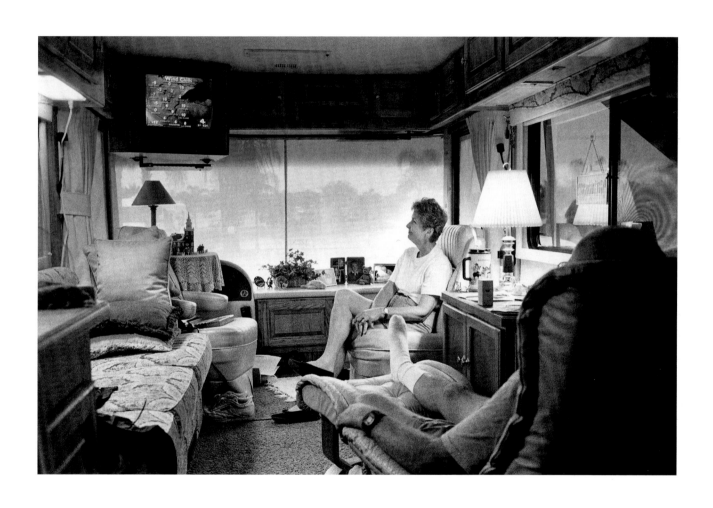

Jan and Dave Dahl of Winona watching weather news from Minnesota via satellite, Crystal Lake RV Resort, Naples, Florida, December 1997

DAVID HEBERLEIN
VISITING STATE PARKS

FOR YEARS DAVID HEBERLEIN HAS BEEN FASCINATED by the phenomenon of national parks—notable natural landscapes that require human intervention to manage and preserve them. This ironic balance is gently handled in his images of Minnesota's state parks: posted signs both caution users about park regulations and teach them about the natural environment; fences prevent too-close interaction with the land's features; and bird feeders appear more enduring than the blur of a passing skier.

The terrain of the parks calls to mind a contemporary definition of landscape as a cultural construction—nature passed through the filter of human agendas. Though our actions may be intentionally benign and respectful, they create an oxymoron—cultured nature. Capturing this phenomenon on film necessarily brought Heberlein into close contact with people, pushing him into what was for him the unfamiliar territory of portraiture. The cool stance possible when photographing human effects at a distance could not be maintained up close. This work thus marks a shift in Heberlein's style toward the compassion and understanding that surface in photographic portraiture. His images of juxtapositions become records of interaction, both between people and the parks and between the photographer and his subjects.

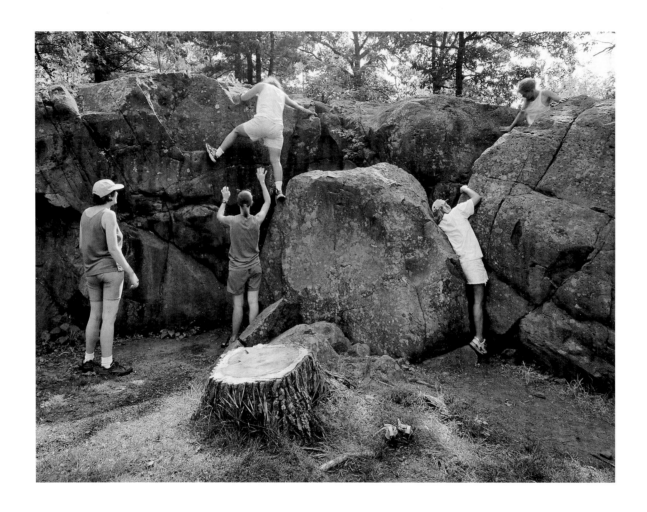

Rock-climbing class, Interstate Park, Taylors Falls, July 11, 1998

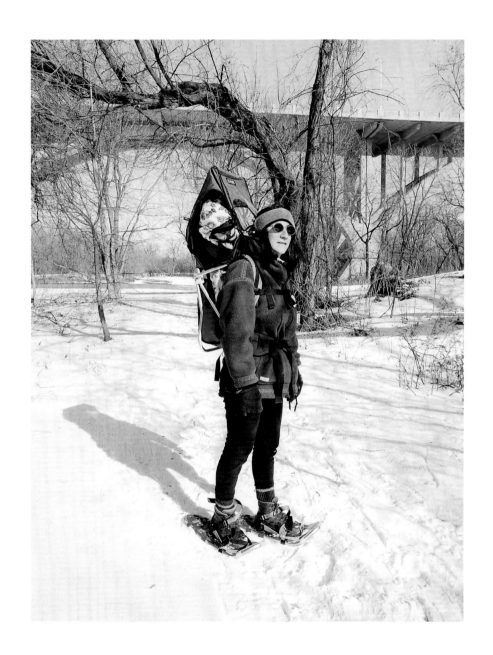

Mother and daughter, Fort Snelling State Park, St. Paul, February 13, 1999

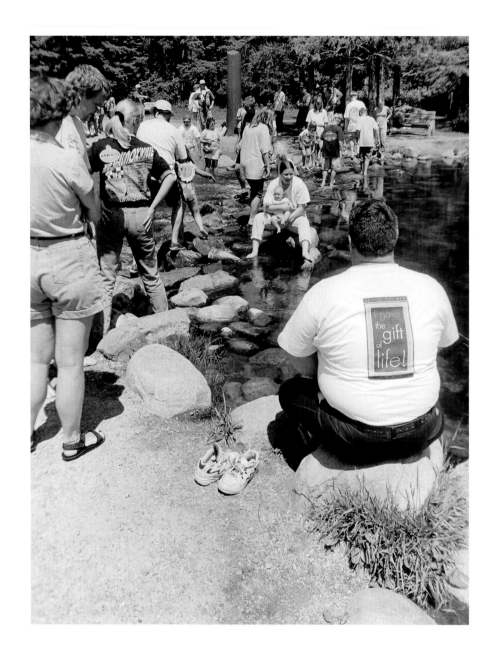

Headwaters of the Mississippi River, Itasca State Park, Lake Itasca, July 6, 1999

Weekend camper, William O'Brien State Park, Marine on St. Croix, July 11, 1999

Geology student, Interstate Park, Taylors Falls, July 11, 1998

Soudan Underground Mine State Park, Soudan, October 7, 1998

89

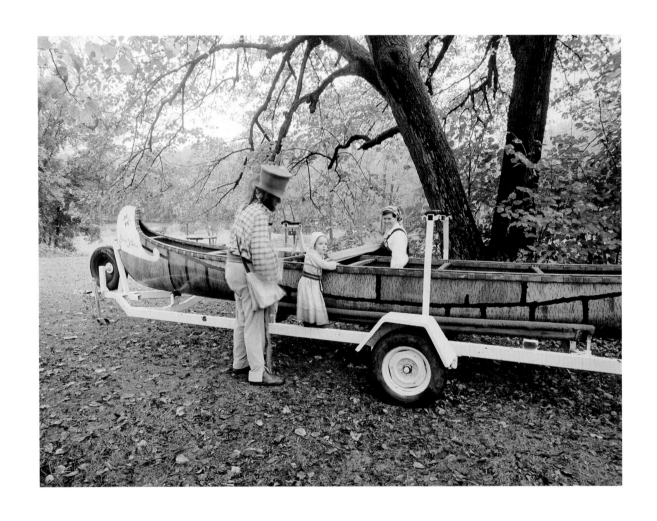

Arriving for a Voyageur Encampment, William O'Brien State Park, Marine on St. Croix, September 26, 1998

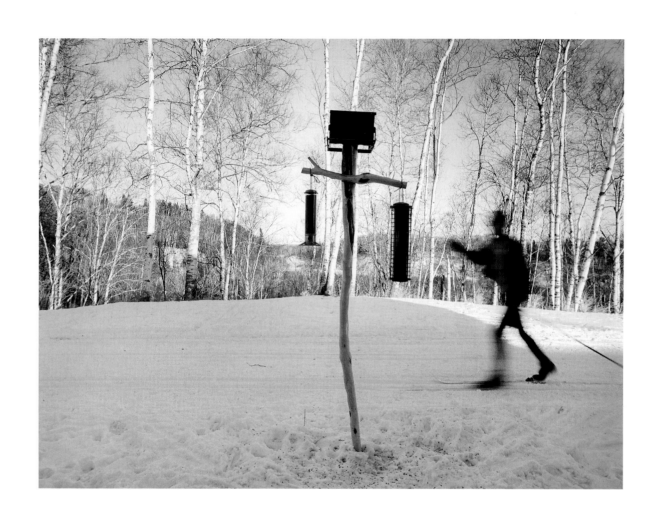

Cross-country skiing, Gooseberry Falls State Park, Two Harbors, February 20, 1999

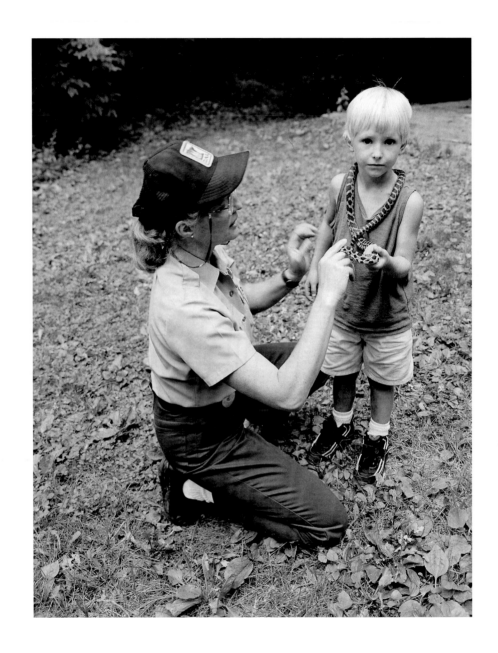

Snake demonstration, Rice Lake State Park, Owatonna, July 4, 1998

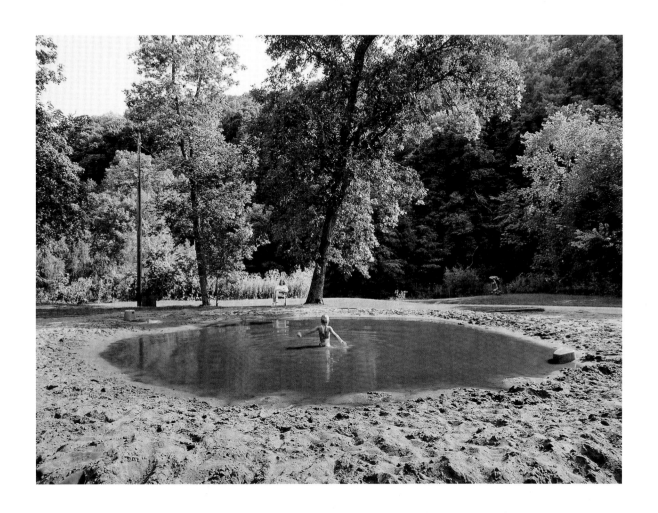

Wading pool, Beaver Creek Valley State Park, Caledonia, July 25, 1998

WING YOUNG HUIE

SMALL-TOWN DIVERSITY

TO GUIDE HIS WORK, Wing Young Huie relies on intuitive responses to his subjects. He often begins his projects by just spending time in a public setting to heighten his visual receptivity, an approach sometimes referred to as street photography. The resulting pictures have a strong subjective quality that communicates Huie's personal passion for and connection to his subjects.

Born into a family of Chinese immigrants in Duluth, Huie has always sympathized with those living outside the predominantly Caucasian culture of the state. For this project he decided to visit several adjoining small towns in southwestern Minnesota where Southeast Asian and Mexican populations had swelled in the 1980s and 1990s. There Huie photographed activities that blend the new and the familiar. Buddhist monks perform ceremonies in a local home, then participants enjoy the Laotian equivalent of potluck. Teenagers hang out in a park, watching their friends in a game that resembles volleyball played with the feet instead of hands. The faces may reflect a broad ethnic palette, but the familiar aura of small-town life is palpable in these images, where romances bloom, firefighters pose in full regalia, churches attract the pious, and everyone gets together for a parade. Huie's homing instinct for community, for the civic glue that holds groups of people together, is expressively present in this work.

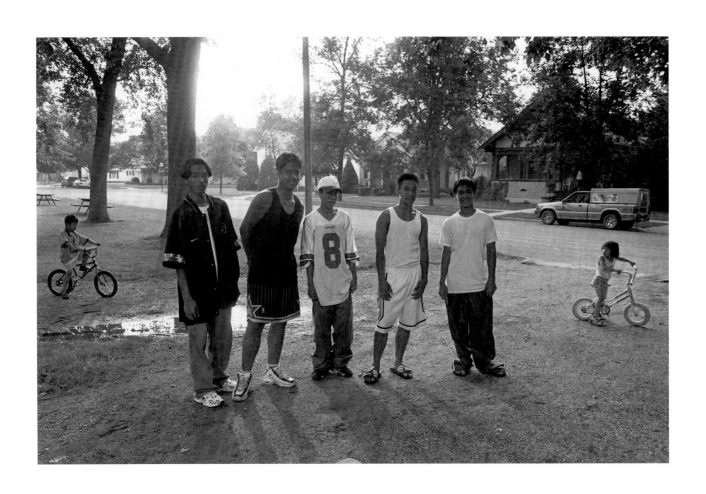

Boys in the park, Mountain Lake, July 1998

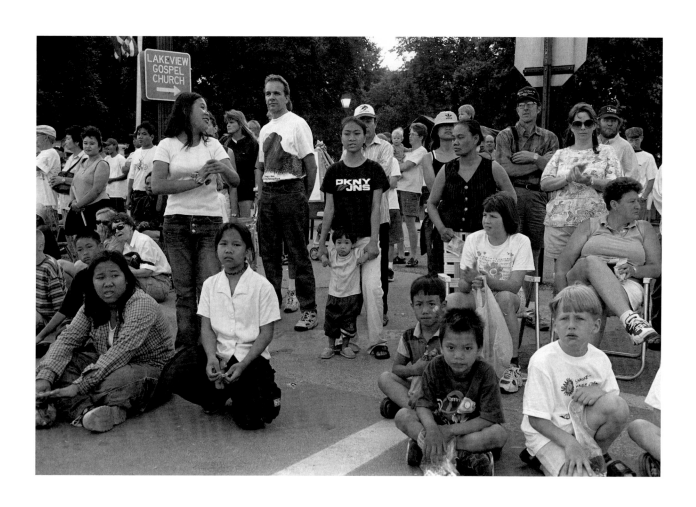

Parade watchers at Powwow Festival, Mountain Lake, June 1999

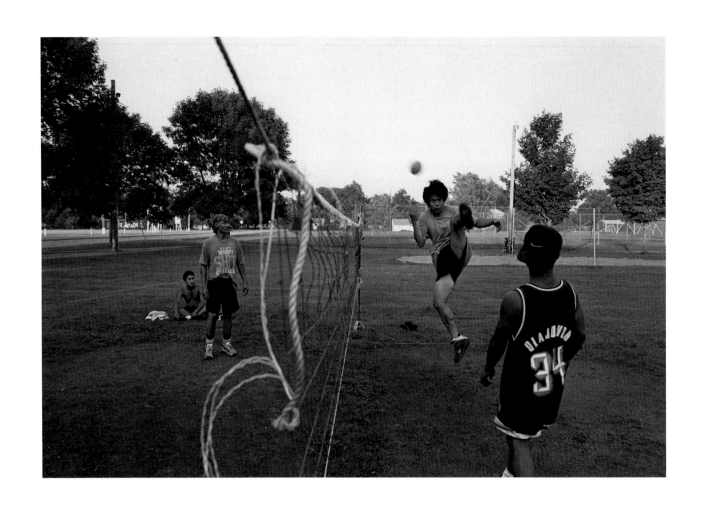

Men playing takraw in a park, Butterfield, July 1998

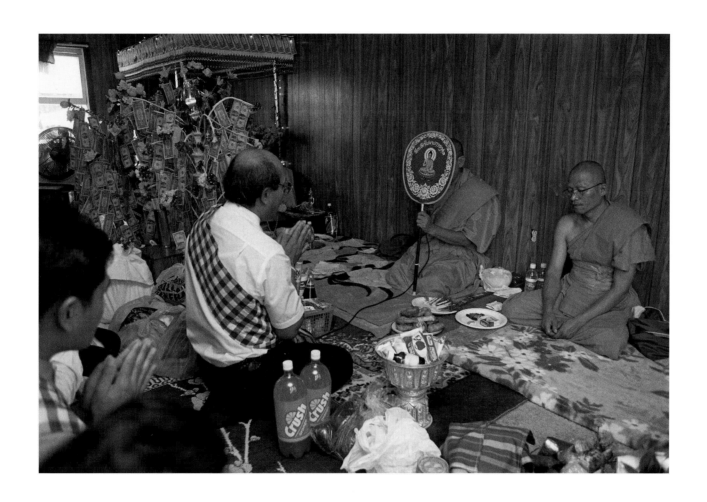

Buddhist ceremony for Laotians, Mountain Lake, April 1998

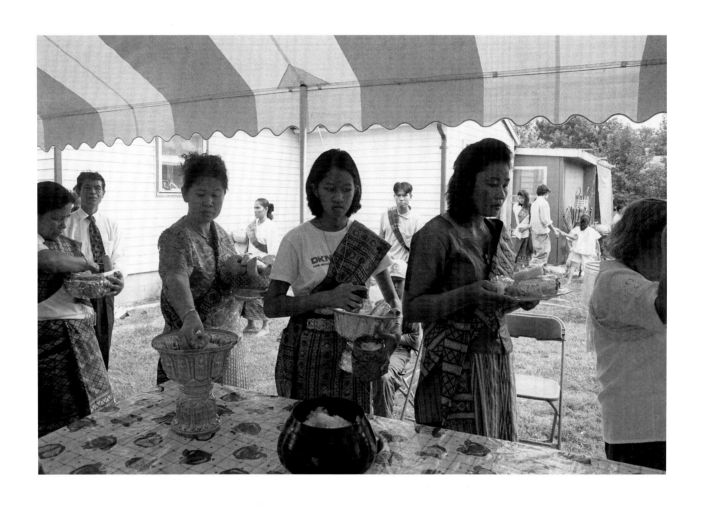

Setting out food after Buddhist ceremony, Mountain Lake, April 1998

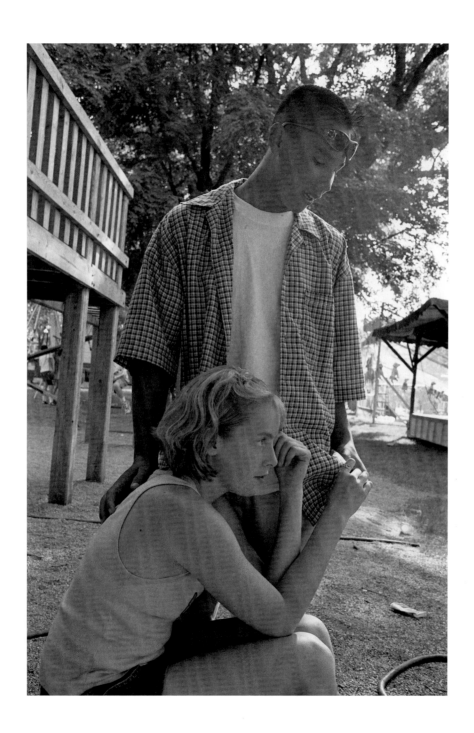

Teenage couple, Mountain Lake, June 1999

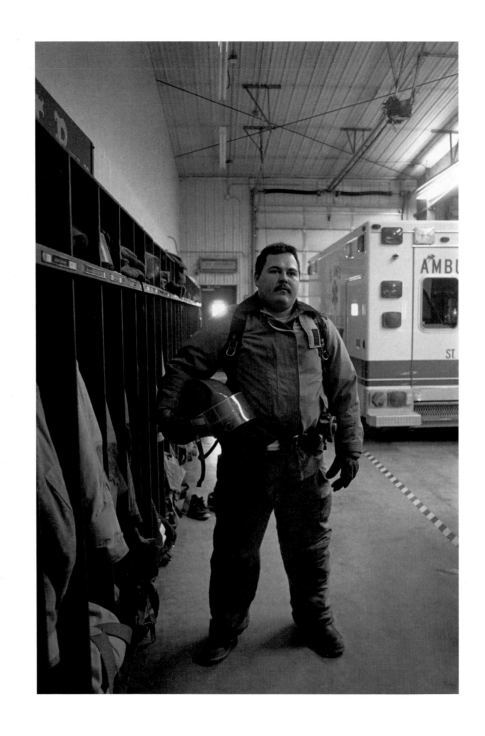

Firefighter José Cruz Carreon, Jr., St. James, September 1998

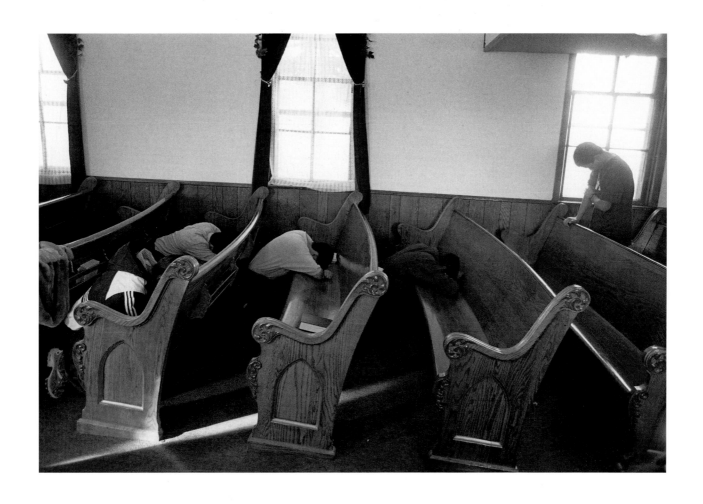

Worshiping at La Roca Pentecostal Church, St. James, September 1998

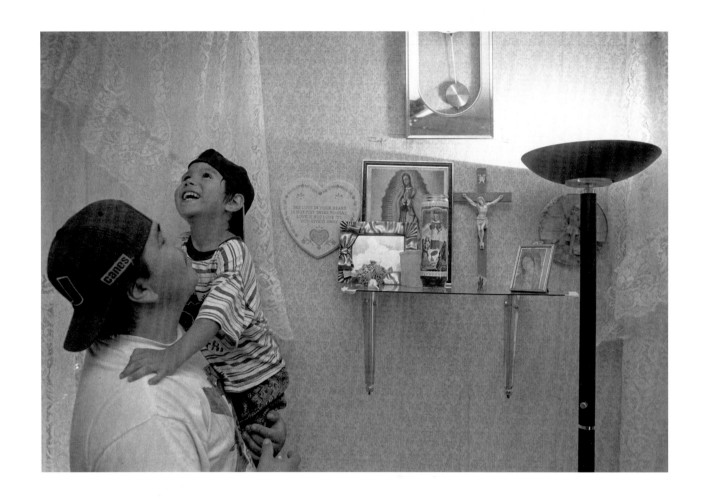

Andres Hernandez and his son in their newly purchased home, Mountain Lake, August 1998

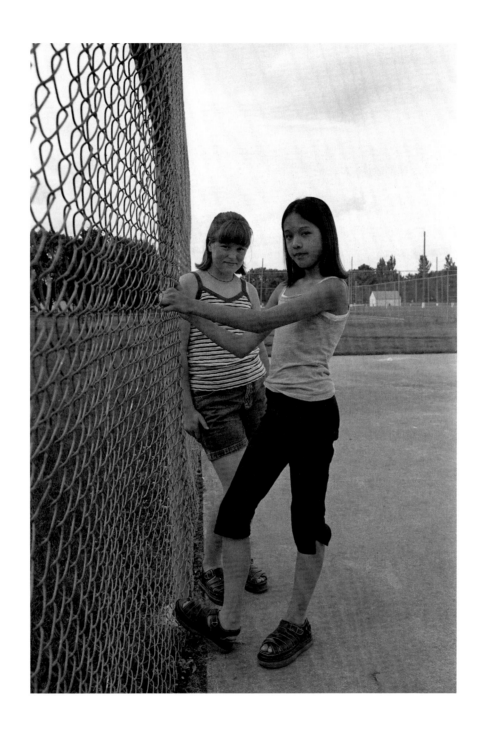

Two friends, Butterfield, June 1999

MARK JENSEN

INDEPENDENT BUSINESSES

IN ATTEMPTING TO REFLECT THE AMAZING DIVERSITY of Minnesota's small-business operators, Mark Jensen faced a daunting task. To meet the challenge, he turned to a collaborative solution—environmental portraits. For each picture, the business owners and operators chose where in their stores they would like to be photographed, then posed themselves as they wish to be seen. The resulting images focus on the relationship between the owners and their stock-in-trade and simultaneously convey information about the past, present, and future of Minnesota's independent businesses. The needs of today's consumers are recorded alongside enduring products and services, and the consumer demands of tomorrow are already evident.

In communities large and small, from the Twin Cities to Lake Superior's North Shore, Jensen has depicted businesses offering everything from smoked fish and pita bread to restored classic cars and American Indian crafts. Despite the prevalence in our times of "big box" superstores, retailers like Wal-Mart have not entirely eliminated small businesses that serve specific customer needs. What the business people in Jensen's photographs reveal is the character of a nonfranchise culture, the support network for those independent-minded consumers that remain. Jensen uses photography's descriptive wealth to create an inventory for future inspection.

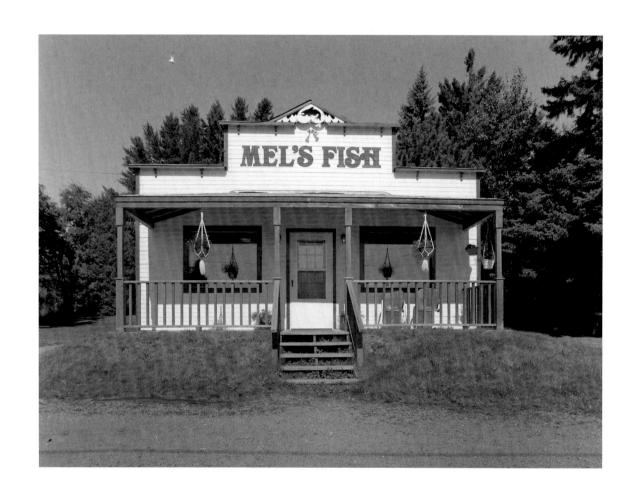

Mel's Fish, Knife River, August 27, 1997

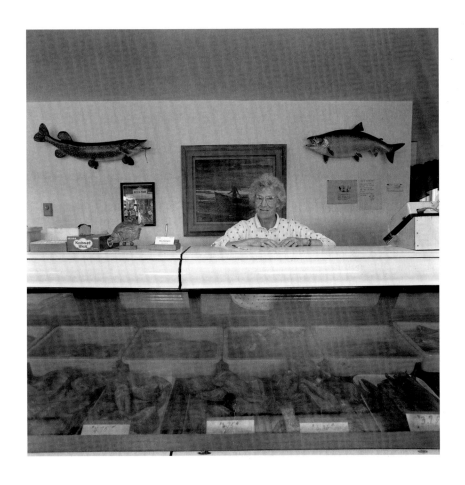
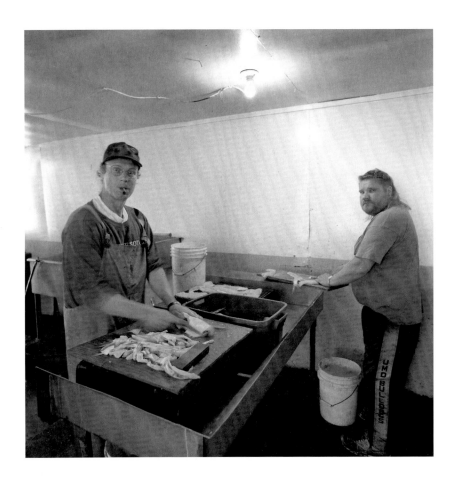

Ethel Wiene, Mel's Fish, Knife River, August 27, 1997
Mark Torgerson and Steve Hanson in the smokehouse, Mel's Fish, Knife River, August 27, 1997

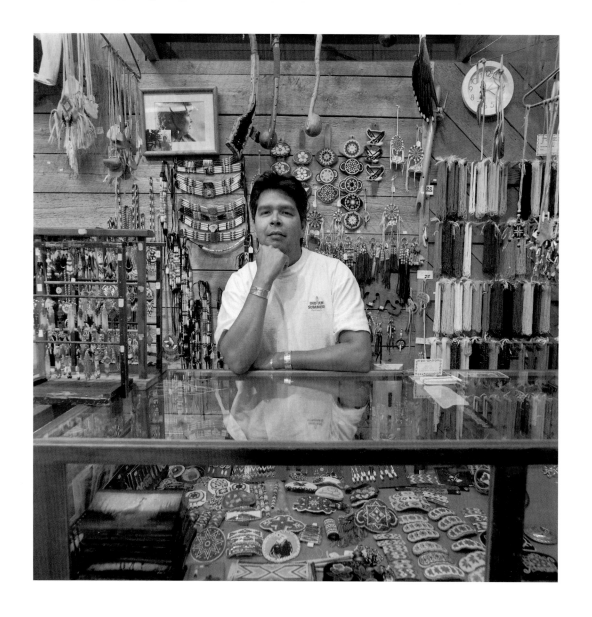

Charles D. Stately, Woodland Indian Crafts, American Indian Center, Minneapolis, September 15, 1998

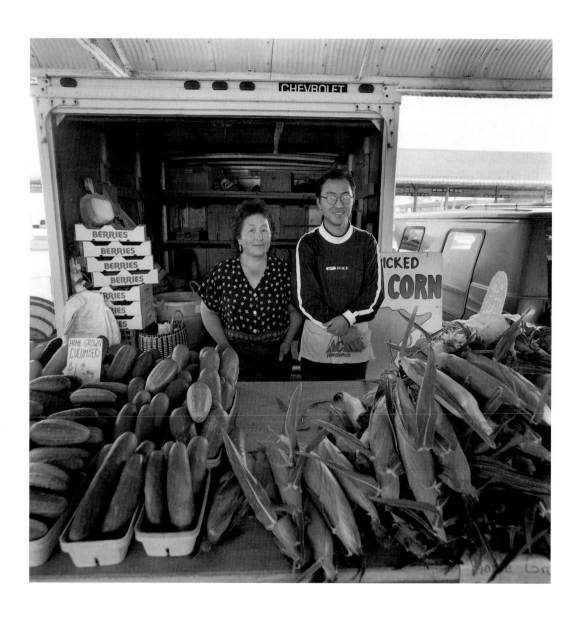

Fang Keu and Sao X. Vang, truck farmers from Hugo, at the Minneapolis Farmers Market, August 1998

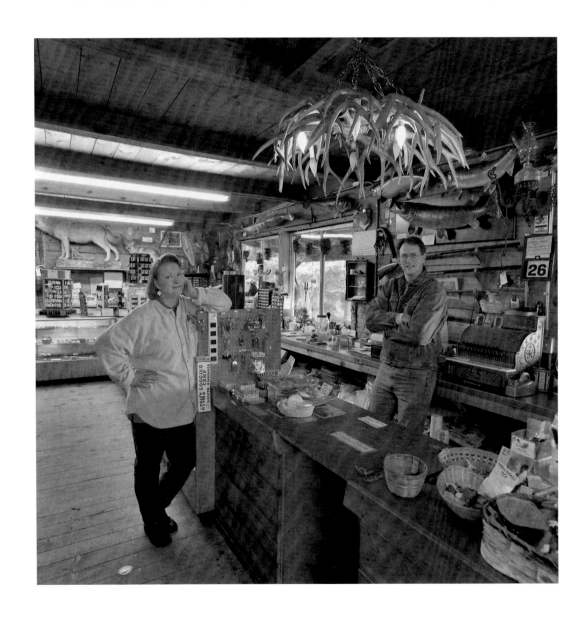

Lauren and Bill Weckman, Tom's Logging Camp, North Shore Drive, Duluth, October 26, 1997

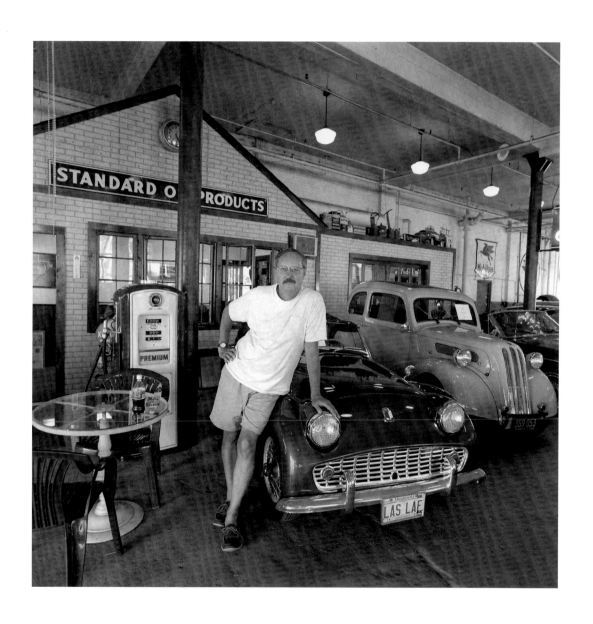

Al Hagen, Yesterday's Autos, Minneapolis, August 1998

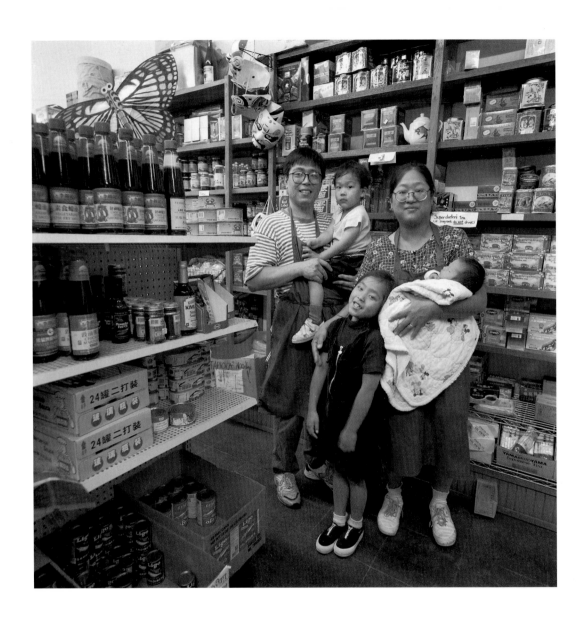

John, holding Harry, Stephanie, and Katherine Park, holding Gabriell, First Oriental Grocery, Duluth, September 1998

Joe Linton, Tom Jenkins with Marina, Michelle Jenkins, and Dan Myhre, Wonderful Muffler Man, Roseville, November 24, 1997

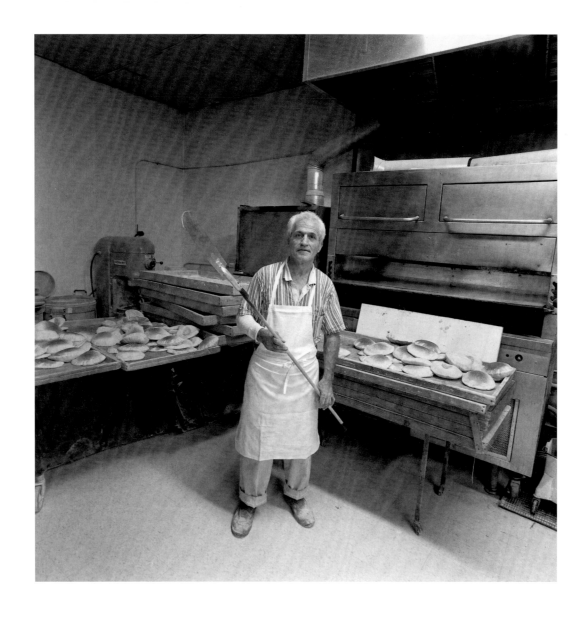

Tony Jerman, Sindbad Cafe and Market, Minneapolis, September 1998

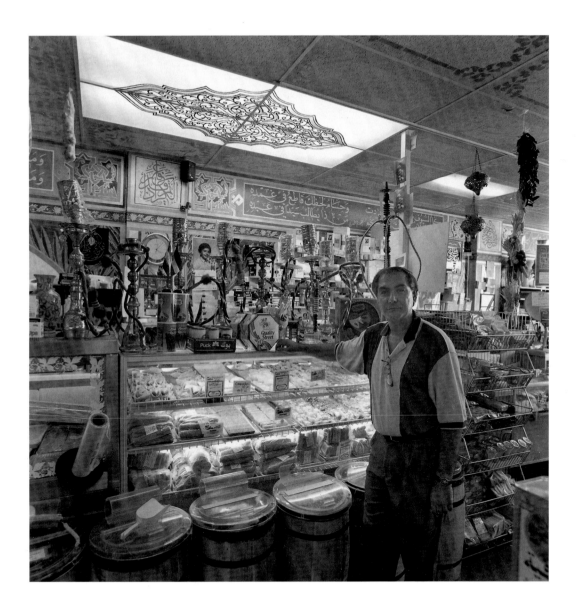

Sami Rasouli, Sindbad Cafe and Market, Minneapolis, September 1998

PETER LATNER

MAIN STREET

PETER LATNER'S PHOTOGRAPHS can be classified as social landscapes. Reflecting issues of architecture, urban planning, and land use, they record the evolving character of "Main Street," a term Latner explores both literally and metaphorically in his images. He is not simply nostalgic for a disappearing way of town life in Minnesota. Rather, he is alert to choices being made that favor automotive over pedestrian interests and that push businesses away from the urban core, transforming the face of small-town Minnesota.

The barbershops, bars, and church basements that Latner encountered might serve as settings in Lake Wobegon, a fictional place with its roots in reality. Other downtown buildings reflect a self-consciously nostalgic view of Main Street. Though adaptive reuse of older buildings helps retain vitality in downtown districts, the hybrid buildings that result often still suggest their former roles in the town's life. A movie theater will always look like a movie theater, even if it has been remodeled into a racquetball club. And memories of watching films there will persist long after the club, too, is gone. Through this collision of history and culture, Latner says, "I began to see Main Street not only as a place but as a backdrop. And as the scene changes, so eventually does the set."

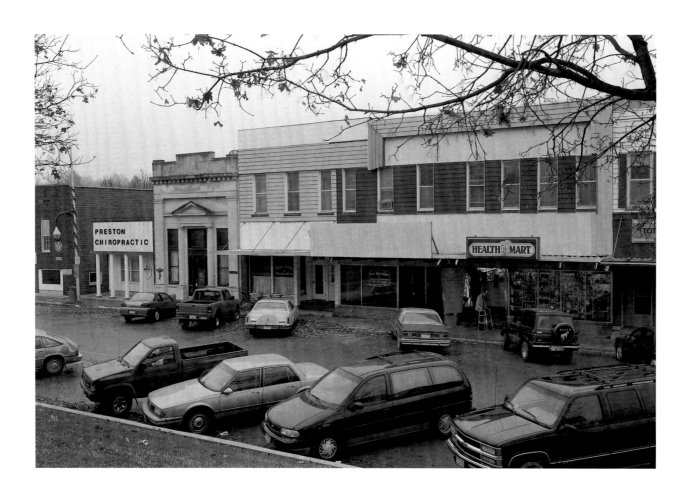

View from courthouse lawn, Preston, November 29, 1997

Outskirts, Owatonna, September 14, 1997

Henderson, November 8, 1997

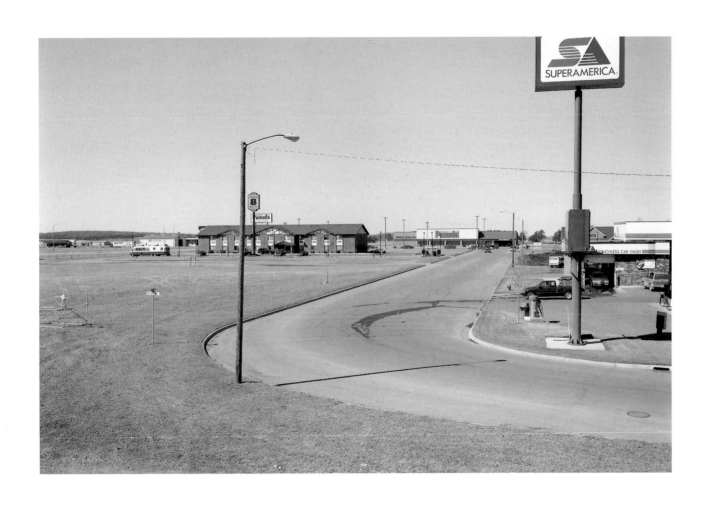

Outskirts along U.S. Highway 10, Perham, April 4, 1998

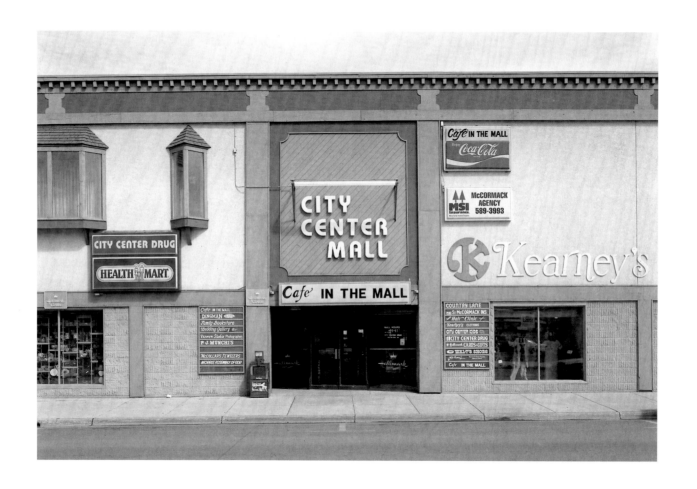

Atlantic Avenue, Morris, September 16, 1997

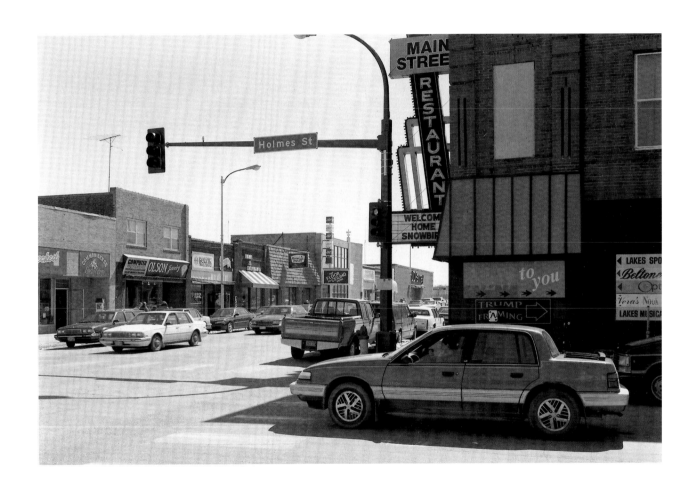

Main Street on Saturday morning, Detroit Lakes, April 4, 1998

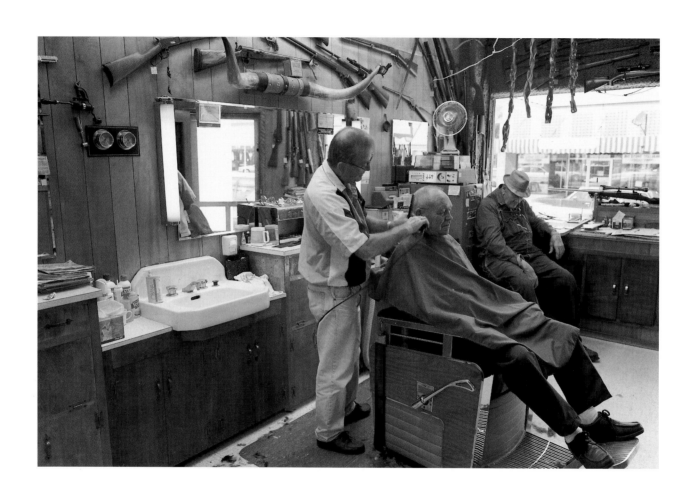

Barbershop, Ortonville, September 17, 1997

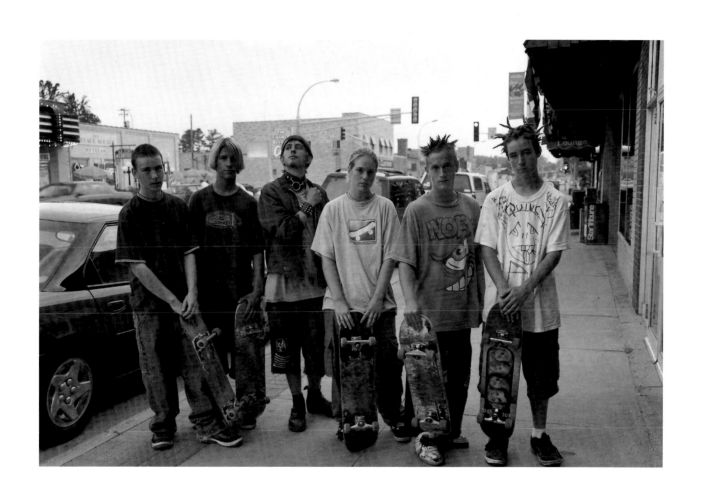

Teens on Main Street on a summer evening, Walker, June 30, 1998

Wheaton, August 31, 1997

Little Falls, July 1, 1998

DAVID PARKER
INDUSTRIAL LABOR

DAVID PARKER, AN OCCUPATIONAL HEALTH PHYSICIAN by trade, first came to know several of his photographic subjects as patients who had suffered work-related accidents. For Parker, his photography meshes perfectly with his "day job": both pursuits are concerned with studying and documenting conditions of work.

The world of industrial labor he records reveals the intensely physical nature of the work. Though computers are used increasingly to direct robots and huge pieces of manufacturing equipment, Parker shows workers still face-to-face with the product of their labor. The environmental conditions in which they toil, from the searing heat of a foundry to the damp chill in a food processing plant, define the work lives of these men and women. And the steel-toed boots, space-age containment suits, and welders' goggles they wear protect them from the imminent dangers of their workplace. Finally, in the endless lines, rows, and piles of products waiting to be handled, Parker suggests the unseen accumulation of labor attached to nearly every object we consume or encounter.

Through his photographs of these workers, Parker expresses his deep personal concern for their everyday experiences and powerfully humanizes the clinical professionalism of his medical practice.

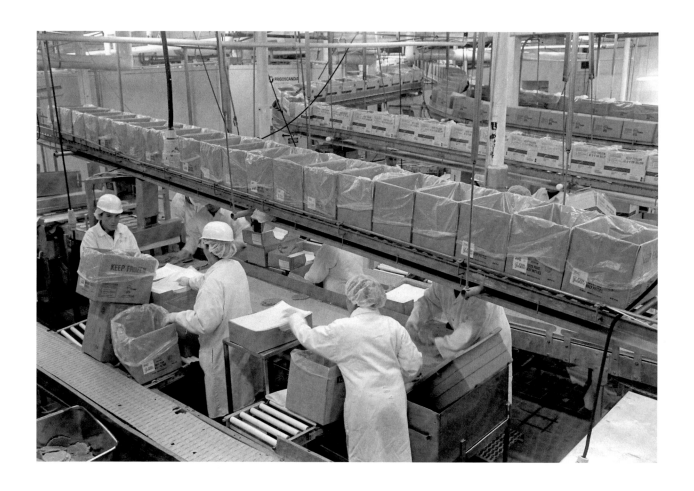

Packing hamburger patties, GFI America, Minneapolis, August 1998

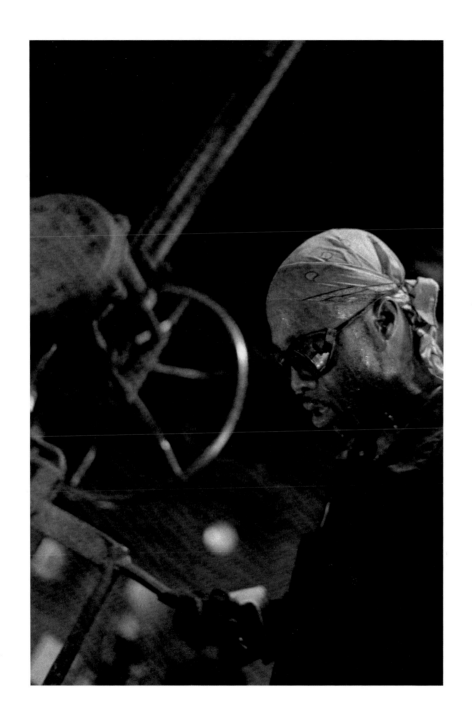

Operating a pouring ladle, Acme Foundry, Minneapolis, July 1998

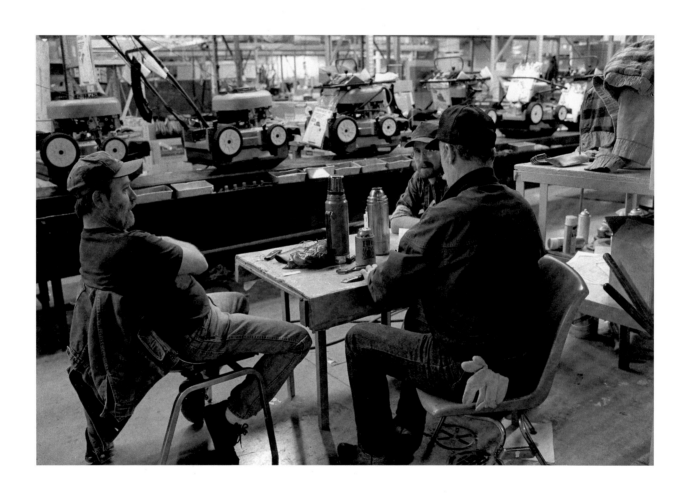

Workers on lunch break, Toro Assembly Plant, Windom, February 1999

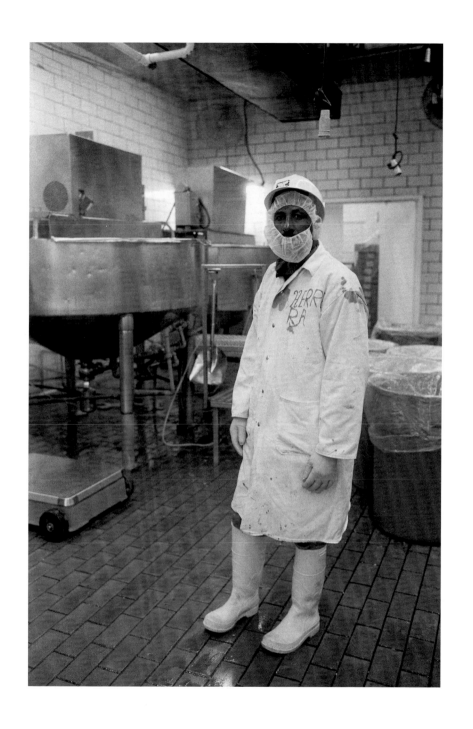

Jaime Herrera in the chili room, GFI America, Minneapolis, August 1998

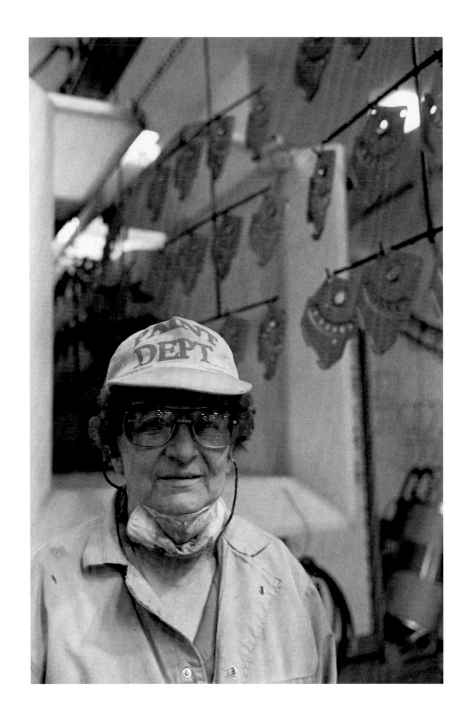

Caroline Schultz, twenty-nine-year Toro employee, on the Toro Assembly Plant paint line, Windom, February 1999

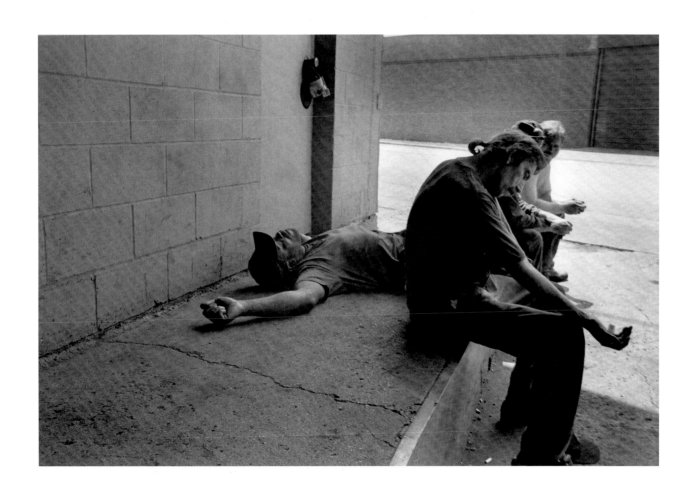

Men on break, Acme Foundry, Minneapolis, July 1998

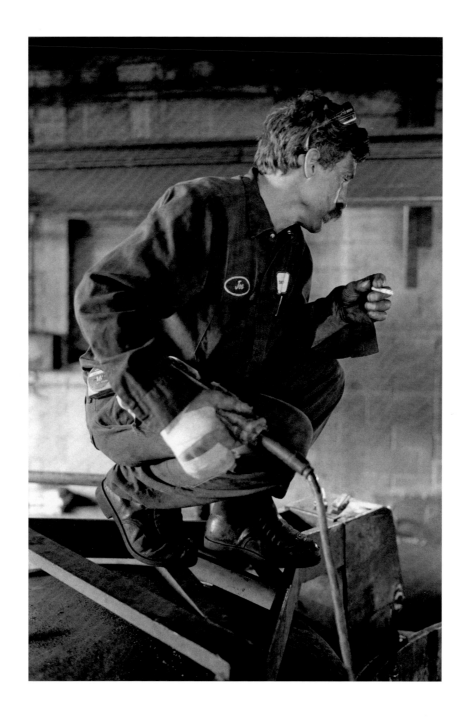

Injured worker adjusting machine, Smith Foundry, Minneapolis, May 1998

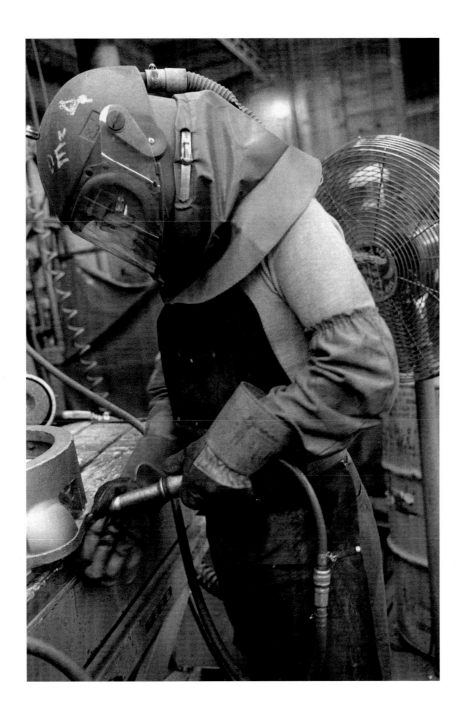

Using a grinder to finish parts, Smith Foundry, Minneapolis, June 1998

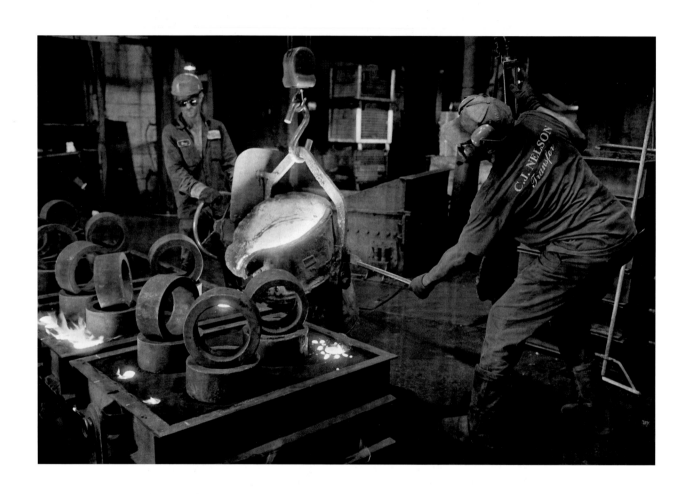

Pouring steel, Smith Foundry, Minneapolis, July 1998

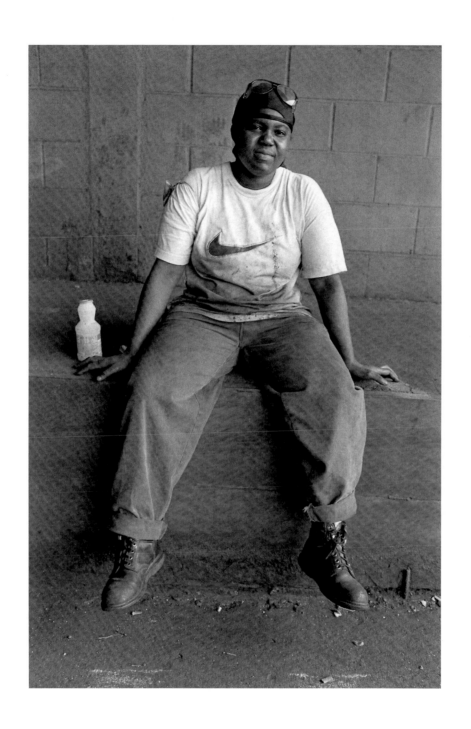

Woman on break, Acme Foundry, Minneapolis, July 1998

KERI PICKETT
TEENAGERS

WITH TEENAGERS CONSTITUTING ONE-SIXTH of the world's population, no one can deny their enormous influence on contemporary society. For her MINNESOTA 2000 project on such a sprawling subject as teenage life, Keri Pickett needed to narrow the focus. Recollections of her own teenage experiences guided her selection of some shots. But the most meaningful suggestions came from teenagers themselves. Pickett relied on them—especially Anne Preller, her subject specialist—to direct her to the people and places they thought most characteristic and worthy of recording in their lives.

These photographs reflect the breadth of contemporary teenage experiences. Job skills training and work are as much a part of life as first loves, self-image, and personal expression. Pickett presents the passionate, appealing forthrightness of teens, whether they're playing pool, running a Boy Scout meeting, rehearsing a ballet, or attending a religious celebration. Each picture manifests the earnest grace of those who, while increasingly self-conscious and critical, are still guided more by emotion than by reason.

Pickett approached her subjects with a clear sense of respect and admiration for those evolving into adulthood. She aimed to record that point in life when youthful bumptiousness begins to assume the contours of maturity. And she sought to reveal some of the maps created by and for teenagers as they move into uncharted territory.

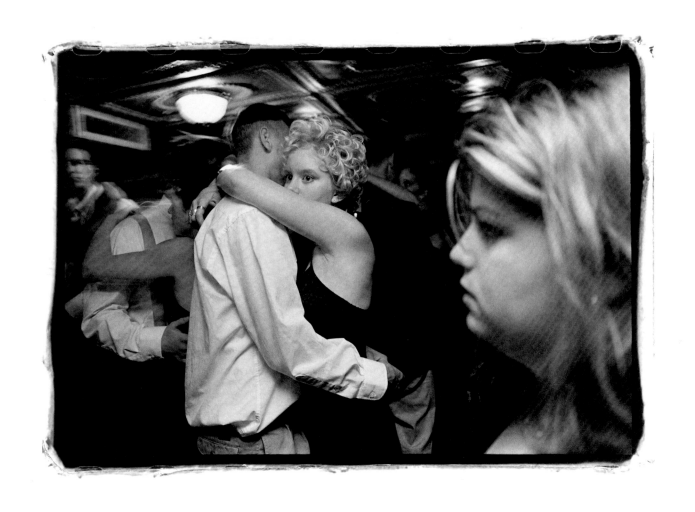

Couple dancing, Young Life dance on a Mississippi River paddleboat, Minneapolis, October 1998

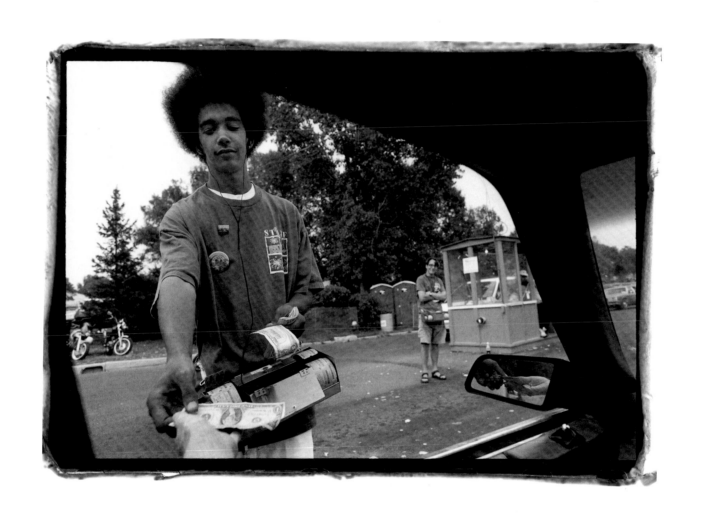

Teenager working gate entrance at Minnesota State Fair, Falcon Heights, August 1998

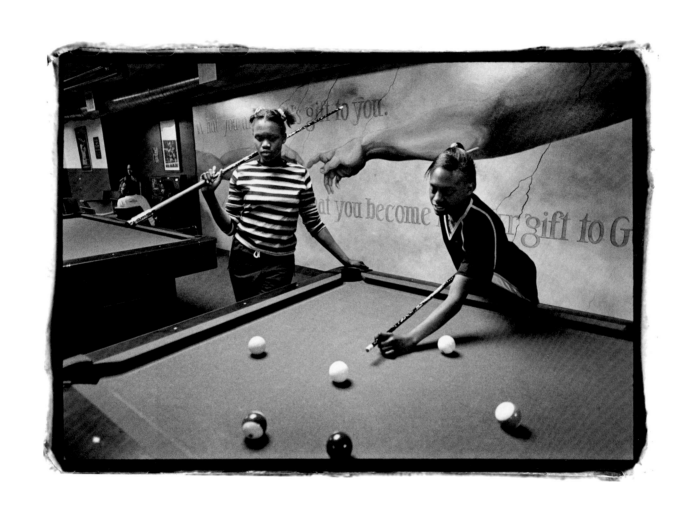

Homeless teens playing pool at Sharing and Caring Hands, Minneapolis, April 1999

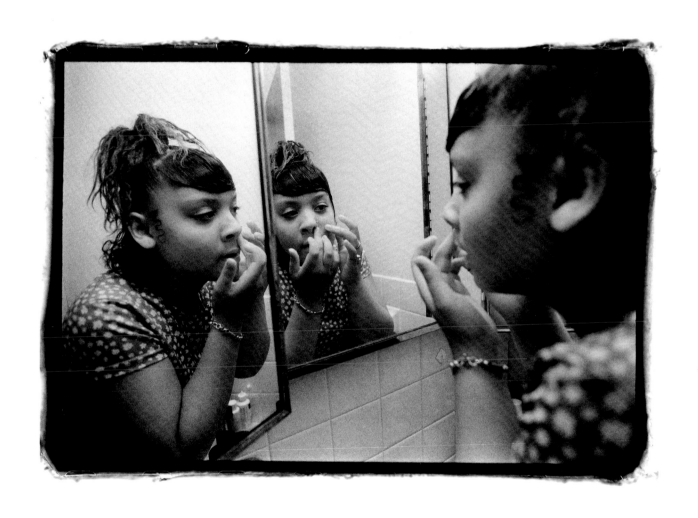

Roxxanne Kubat, 13, primping in her sister's south Minneapolis apartment, August 1997

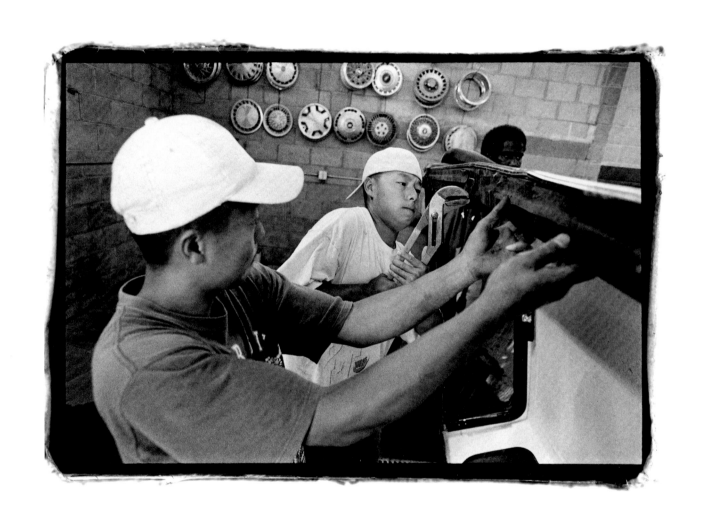

Brothers learning automotive repair at Newgate School, Minneapolis, May 1999

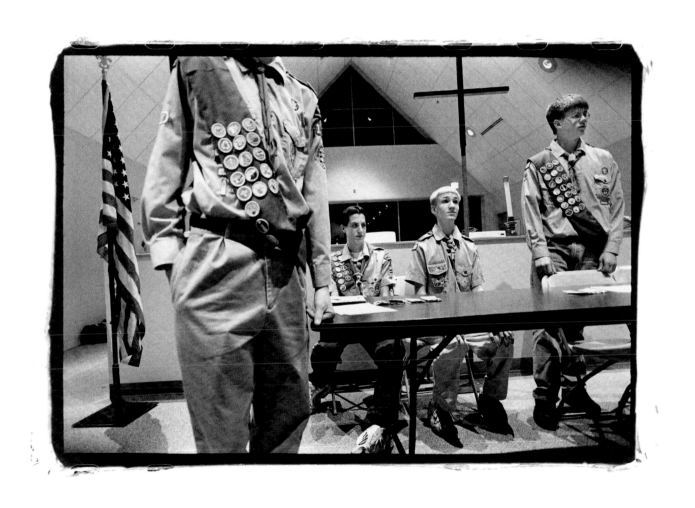

Eagle Scout and merit badge ceremony, Bethlehem Lutheran Church, St. Cloud, October 1998

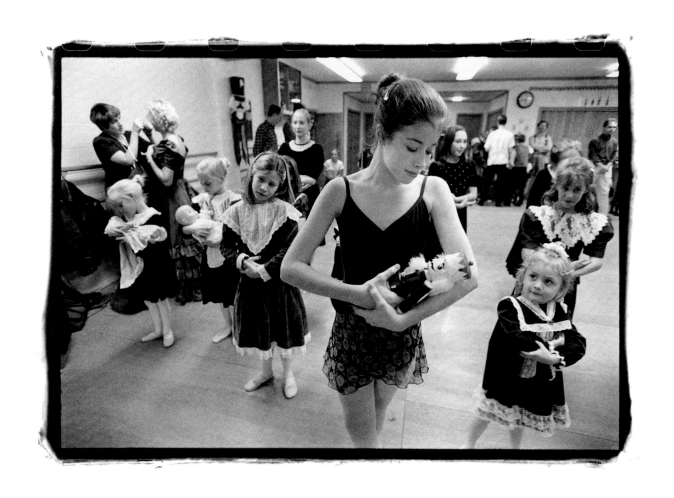

Cicilia Loom, playing Clara, during dress rehearsal of The Nutcracker, *Stillwater, November 1998*

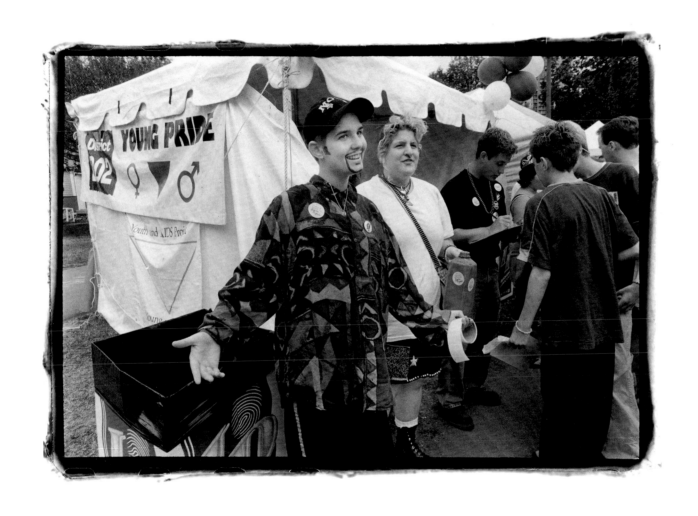

Jill Adams, 16, as "Pedro" at District 202 tent, Pride Festival, Minneapolis, June 1999

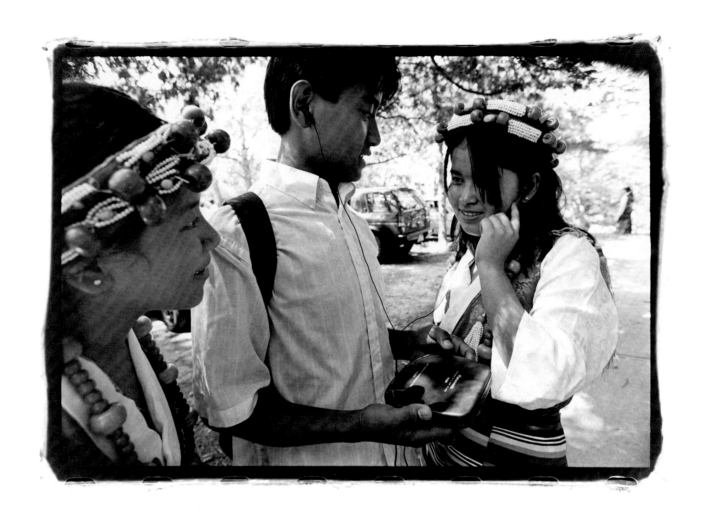

Teens at Theodore Wirth Park to celebrate the birthday of the Dalai Lama, Minneapolis, July 1998

Heather Kennelly, 18, and Stephen Daniel, 16, on a walk near Wolf Lake, August 1998

NOTES ON THE PHOTOGRAPHS

COMMENTARY ACCOMPANYING THE PHOTOGRAPHS in this book was kept to a minimum in order to emphasize the images themselves. The photographs are the primary texts here.

Contained in the archives of the MINNESOTA 2000 project, however, is a wealth of materials that shed light on the photographs—information about the artists, their processes, and their subjects. Foremost among the supporting materials are transcriptions of interviews with each of the twelve photographers conducted after submission of their work. The interviews, which the project advisors referred to as "debriefings," allowed the photographers to speak broadly about the execution of their project and specifically, with prints in hand, about each of their thirty images in the final selection. Their comments help characterize their approach to their project, whether personally reminiscent (as in the cases of Arndt and Pickett, for example), detail-oriented (Dahl and Heberlein), or professionally insightful (Parker).

The following texts are intended to provide another dimension to the reading of selected photographs. Some of the quoted material has been edited from the transcripts. We have respectfully sought to retain the tenor of each photographer's words while acknowledging the desirable goal of readability. Consequently, although presented here as quotations, the comments are to some degree paraphrastic.

Other sources for the notes include labels prepared for the Minnesota Historical Society's exhibition of MINNESOTA 2000 photographs and nondebriefing comments by the photographers. All materials, including comments offered by the subject specialists assigned to each photographer and printed ephemera such as journal and newspaper clippings, are accessible in the MINNESOTA 2000 project archives at the Minnesota History Center Library in St. Paul.

These excerpts should be read as enticement to pore through the complete files, which also contain additional work prints that contribute to a fuller understanding of the myriad choices, esthetic and pragmatic, made en route to the completion of this project.

JOSEPH ALLEN
URBAN INDIANS

PAGE 14

Mary Johnson's bingo night at the American Indian Center, Minneapolis, August 1999

Johnson, from Leech Lake, is widely known in the Minneapolis Native American community. She serves meals to elders daily, both at the center and in their homes. She goes to Bingo every Tuesday and Friday night, often with her son, seated across the table. The small animals on the table are her lucky charms.

Allen: "I wasn't hesitant [about taking the picture]; this is a stereotype but I think everyone will love it. Jim Northrup joked that the Ojibwe word for bingo is 'jermawyn'—'Did yer ma win?' And artist Eva Two Crows made a mask she named 'Granny Winsalot.' It's a cultural phenomenon; everybody's got a bingo grandma. It's not all Indians at this bingo; it's black and white, not too many Asians. It reflects the community around [the center]—Somali, Indian, a little bit Hispanic, and white."

PAGE 15

Yako Myers, competitive weight lifter, practicing at The Gym, Plymouth, January 1999

Myers, a social worker of Ojibwe and Mohawk ancestry, has a multitude of interests. Besides her job with the Minnesota American Indian AIDS Task Force and her weight lifting, she is a writer, storyteller, bow hunter, and avid organic gardener. In 1999 the McKnight Foundation gave her a Virginia McKnight Binger Award in Human Service for her extensive volunteer efforts in the community.

Allen: "Yako does competitive weight lifting in the Minnesota State Power Lifting Association. They do dead lift, bench press, squat, clean and jerk. She's one of the few women in the state who does this. When I went [to photograph her competition], there were fifty or sixty guys and only five or six women."

PAGE 16

Frederick Matt family, Little Earth housing project, Minneapolis, July 1999

Allen: "The Little Earth housing project in south Minneapolis used to be owned by Housing and Urban Development. Then the residents' association bought it. You pay rent according to your income. So if you start making money, you move out of there. It's the place where people start out if they're moving into the community.

"Frederick works sporadically, mainly supplementing the family income through beadwork and crafts, selling earrings door-to-door. A lot of families survive that way."

PAGE 18

Eric Keast painting sets with youth from the Phillips neighborhood, American Indian Center, Minneapolis, August 1999

Keast designed sets for an AIDS Awareness play produced by the Minnesota American Indian AIDS Task Force.

PAGE 19

Yako Myers working at Pillsbury Neighborhood Services' Waite House, Minneapolis, August 1999

Here Myers distributes AIDS pamphlets, condoms, dental dams, and flavored lubricants. Allen reported that the service ran out of watermelon flavor that day.

Allen: "Her main job is outreach and education—teaching people, trying to get people to come in and get tested for HIV. It's a pretty big concern in the community."

PAGE 20

Donovan Goodman and Terry Mousseaux's wedding limo, Minneapolis, May 1998

Goodman, of Minnesota's White Earth reservation, and Mousseaux, from the Pine Ridge reservation in South Dakota, were married at Holy Rosary Church. The ceremony blended Catholic and Native traditions, included drumming, and the couple exchanged vows wrapped with a star quilt. They separated later that year.

Allen: "I think the whole wedding party rode in this limo. There's no clue here that they're Indian. Terry hitched her dress up a little bit to show that garter. The driver told me about this angle: 'Hey, you want to get in the front seat and look back.' This was his view in the rearview mirror. Terry left Donovan around Thanksgiving of 1998 and moved back to Pine Ridge. They were in the process of getting a divorce when she was killed in a car accident."

PAGE 21

Eric Keast in his studio with his painting Y2K, Minneapolis, January 1999

This work is painted in shades of orange, red, and green and adorned with found items. The border is made from commercial photographs of butter that Keast discovered in the trash.

THOMAS ARNDT
BY THE LAKES

PAGE 24

Jogging along Lake of the Isles, Minneapolis, June 1999

Arndt: "I liked the geese, so I set up and then saw this woman running through the frame. One shot."

PAGE 25

Fishing season opener, Mille Lacs Lake, Garrison, May 1999

Arndt: "This is very spiritual, Michelangelo-esque—like his painting of creation, as they reach out to get into the boat. It's a very delicate dance; the last person in always has to do it. Notice all the boats out on the horizon. These guys probably went out at midnight, came back in and slept, and now they're going out again. I thought about going out on a boat—I did a lot of fishing when I was a kid. Tons. But I just got fished out. [Governor Jesse Ventura] was fishing on a nearby lake. I had a spot on his boat but I didn't want to be out there at a publicity event for six or seven hours."

PAGE 26

Beach life, Lake Nokomis, Minneapolis, June 1999

Arndt: "I photographed [smaller parts of this scene] but then I saw these guys coming, and I had a 20mm lens zone-focused, and I thought, 'That's it, that's my frame.' You've got to try to notice everything."

PAGE 27

Father and son in an ice-fishing house on Mille Lacs Lake, February 1999

These two Ojibwe men live near the lake, which has provided their people with food for many generations. Arndt spent a day with them in their fish house a half-mile from shore.

Arndt: "The fish house was unbelievably small, refrigerator-crate-sized. They caught a lot of perch—threw them back. You really don't want perch, you want walleye."

PAGE 28

Fishing contest workers, Red Wing, September 1998

Working at the annual North American Walleye Anglers' fishing tournament, these friends tie up the boats of winning contestants as they come in from Lake Pepin. The two are saving up for a boat and hope someday to win this contest.

Arndt: "Maybe they'll never get the money for a boat. But they have these dreams, see. And they were very good at helping. Yeah, they were very sweet."

PAGE 32

Two men, Lake Calhoun, Minneapolis, June 1999

[Q: Do you talk to your subjects as you approach them?]

Arndt: "It depends. The African American guys walking around Lake Calhoun had just seen me take a picture of some kids. They were curious about me, and I was able to work quickly enough to make this picture. And the light . . . a lot of photographers wouldn't even photograph with the subject here and the sun there. But I, being a legend in my own mind, don't pay any attention to that stuff. I just lay in enough exposure for the shadows, and I can bring everything in so it's right. In the final print, I did almost no dodging or burning—it's just the light."

STEPHEN DAHL
TELECOMMUNICATIONS WORKERS

PAGE 36

Circuit-board inspection worker behind a magnifying glass, ADC Telecommunications, Minnetonka, August 1998

Dahl: "This woman is the first to do a visual inspection after a robotic machine sets electronic pieces on a circuit board. I photographed her from a couple of angles. Here I was playing off the magnifying glass, waiting for her to be framed by it."

PAGE 37

Carl Holmes, machinist for ADC Telecommunications, Shakopee, July 1998

Holmes has been with ADC for twenty years. The safety-conscious company provides him with earplugs and a device to monitor air quality. Here he repairs a 100-year-old lathe that out-performs some newer high-tech models.

Dahl: "He was right in front of a window and I perched on top of a bench to get a direct-on view of him. I just wanted to get his strength."

PAGE 39

Pause in a paint booth, ADC Telecommunications, Shakopee, July 1998

Dahl: "The line moves past these people using paint guns to spray small parts. At first I was worried about getting my camera equipment covered in paint, but I found out they use an electromagnetic system that enables the paint to adhere just to the plastic parts."

PAGE 40

Plastic-injection-molding machinery, ADC Telecommunications, Shakopee, July 1998

This is what a state-of-the-art factory looks like at the end of the twentieth century, with high-tech machinery in a clean, well-lit place. Debris and fumes are immediately sucked away by the tubes surrounding the machines. A solitary college student, working as a summer "temp," monitors the machines.

Dahl: "A lot of my images focus tight on people. But sometimes I have to step back and get an overview. And a lot of times those images are more powerful. Here the environment is more dominant than the person but I was really aware of him and how the light was falling on him."

PAGE 41

Circuit-board assembly line, ADC Telecommunications, Minnetonka, August 1998

Dahl: "There are a lot of Somali workers here. This image shows the boredom of line jobs. The black boxes hold parts and the circuit boards slide along the silver rail. The guy on the right has a strap on his left wrist that grounds him to the table so the electricity in his body won't affect the boards. It was pretty quiet on the line. There was no canned music but some people brought their own music and earphones."

PAGE 42

Pulling fiber optics cable, Spalj Construction Co. installation crew, Minneapolis, January 1999

Dahl: "This gives you a good idea of what fiber optic cable is. It's thick but the fiber itself is thinner than a hair—there are hundreds of strands of fiber optics in that cable they're laying. This guy was trying to straighten out a twisted cable. The workers are transient; they're going to Texas next. They subcontract and go where the work is."

PAGE 43

Temporary employees testing for permanent work eligibility, ADC Telecommunications, Hopkins, September 1998

Dahl was surprised to encounter a great many temporary workers in the course of his photo study—a sign of the uncertainty that many employees face. Here workers sign up to take a basic-skills test that could lead to a permanent position with the company.

Dahl: "I work in public education dealing with similar issues so I probably put on a different hat there in the testing room. I was concerned about not disturbing their test-taking so I didn't stay around taking pictures as long as I usually would have."

PAGE 44

Hair dryer, Rolm Resale Systems, a division of Norstan, Maple Grove, July 1998

Dahl: "This is one of those images that just struck me when I saw it. A lot of my pictures have more to do with assembly lines, perspectives showing rows of people—composed images. In this one, I was open to seeing this man in a kind of quiet, sad moment. He's using a hair dryer to remove labels from phones, one after another.

"I was struck by the mood more than anything. When I photograph, I'm up front about asking permission. I had done several images of this man already that day, and I knew he was okay with me photographing him. I probably wouldn't have taken this picture had I not approached him before, because I would have wanted to respect his right [to a quiet moment]."

PAGE 45

Woman leaning on hand, ADC Telecommunications, Hopkins, July 1998

Dahl: "Most of these images just occur. I get excited about individual faces but I'm also interested in the unexpected. I may look at locations or activities and decide whether I want to take a picture there. But the actual incident I photograph I don't want to figure out ahead of time.

"This woman is taking a moment for herself, leaning on a rack of circuit boards. It was hard to get an image like this because people were worried about being photographed when they weren't doing anything."

CHRIS FAUST
ALONG THE MINNESOTA RIVER

PAGE 48

Cedar Avenue Bridge over the Minnesota River, Burnsville, August 1997

Faust: "I found the neat, ordered landscape interesting, with the rocks [placed there to block vehicles], the sign, and the big geometric shapes of the highway. I didn't know there was a state park here. I just followed a road [from the Black Dog Generating Plant] and it turned into this. I like doing that—taking a road to see where it goes."

PAGE 49

Constructing a new dike near old Carver riverboat landing, October 1998

This landscape has undergone dramatic change. The streets of Carver once sloped down to the landing, seamlessly connecting town and river. Periodic flooding necessitated building dikes that cut Main Street off from the river. This photograph shows the most recent of the earthen dikes under construction.

Faust: "The structure on the right is a nineteenth-century building that's been converted. You can see old and new Carver here. It's really Twin Cities suburbia up on top of the bluff."

PAGE 52

Freeway ramps leading to the Mall of America off Killebrew Drive, Bloomington, February 1999

Few visitors to Minnesota's most popular tourist attraction realize that the Mall rises near the Minnesota River.

Faust: "They don't like photographers out there at the Mall, so I was trying to avoid the security cameras. And I like the sign—'120-foot buffet.' The river is at my back about a mile away."

PAGE 53

Campers Josh and Jay in a Renville County park near Morton, June 1998

These two students from Mankato State University, surrounded by a profusion of camping paraphernalia, wait for their buddies to arrive.

Faust: "They were just the advance guard. They had a lot of coolers—offered us a beer but the light was good so we just kept going."

PAGE 54

Black Dog Generating Plant, Burnsville, November 1997

Faust: "I shot this from a boat with a hand-held camera. It's a romantic shot of a nonromantic scene. The port isn't being used, but the plant has a rudimentary barge dock so it can still get coal if there's a rail strike."

PAGE 57

D & A Truck Line, New Ulm, June 1998

At the turn of the last century, train cars would have lined up on these tracks. Now trucks have largely replaced trains as the main means of transporting agricultural products out of the fertile Minnesota River valley.

GEORGE BYRON GRIFFITHS
RAISING AND EDUCATING CHILDREN

PAGE 60

Latesa Sykes with martial-arts instructor Susan Budde, Minneapolis, April 17, 1999

Griffiths: "[Subject specialist] Marti Erickson loved the F.E.M.A. [Feminist Eclectic Martial Arts] images, which she felt needed to be included to show girls' involvement in sports and physical activity. She also thought this training was likely to serve as self-defense skills for the girls as they grew into womanhood."

PAGE 61

Troy Williams with Troy, Jr., before work, St. Paul Companies Children's Center, St. Paul, April 15, 1999

Because his son's day care center is located in his workplace, Williams begins every weekday playing with his son. He spends most lunchtimes with him as well. Williams left a successful career as a musician to become an insurance underwriter because he didn't want to be on the road while raising a family.

PAGE 62

Vicki Robinson, her son Peter, and daughter Maggi shopping for shoes at Target Greatland, Edina, August 27, 1998

Griffiths: "Peter spent all summer wearing sandals. Now it was time for a little back-to-school shopping—he needed white-soled shoes for gym class. Vicki is helping him find his shoe size with the foot-sizing chart on the floor."

PAGE 63

Tony Nelson watching his fourteen-year-old son, Joe, wash a semitrailer, Deerwood, March 26, 1999

Griffiths: "Joe is home-schooled in the morning, then works at the family trucking business every weekday afternoon from 2:30 to 5:30. He makes six dollars an hour."

PAGE 64

Coach Dave Galovich talking to his Crosby-Ironton team during halftime of a game against Greenway-of-Coleraine, Crosby, January 26, 1999

Griffiths: "At halftime Crosby-Ironton was ahead 37–26; they went on to win the game 77–56. The boy behind the coach is ninth-grader Eric Hoge, one of the team managers. Eric's duty is to be in charge of the water bottle for his brother John, a senior, sitting next to Coach Galovich."

PAGE 65

Jay Parmeter working with daughter Zoe on his lap, Crosby, December 14, 1998

Parmeter conducts a successful executive and technical recruiting business from his boathouse office on Serpent Lake. He is also the primary caregiver for his daughter, a kindergartner, while Zoe's mother works for the local school district. Zoe has her own desk adjoining her father's.

PAGE 67

Starbase Minnesota instructor Mike Niemi with students Katie Blossom, Michael Spann, and Ding Thao, Air National Guard Base, St. Paul, May 12, 1999

Starbase Minnesota, a nonprofit organization, offers learning experiences in aerospace science, math, and technology to inner-city students in grades 4–12.

PAGE 69

Pam Stock, a teacher on maternity leave, with her daughter, Sydney, Brainerd, April 8, 1999

Griffiths: "Pam, the Special Education teacher at Cuyuna Range Elementary School in Crosby, was 36 when she had Sydney. She took maternity leave from her delivery date on November 19, 1998, to February 1. She went back to work for about a week, decided she wanted to be with her daughter, and took unpaid leave until the end of the school year. It's important to Pam to have things around that provide extra stimulation for Sydney's development. Here she was teaching Sydney to roll on her back and reach for objects hanging overhead."

TERRY GYDESEN
SNOWBIRDS

PAGE 72

Ed and Doris Lundberg from Detroit Lakes by their trailer, Quartzsite, Arizona, January 1999

Gydesen: "As places like Apache Junction fill up and no more trailer parks can be built in Phoenix, developers move on to areas like Quartzsite. In the main RV areas there, you pay $100 a season for water and for garbage and toilet dumping. There are free areas, too, where you can stay if you're totally self-contained. When you leave your spot to drive into town for the day, you just set out a lawn chair or put up a sign to mark it while you're gone. People generally respect that.

"The Lundbergs are in their eighties now. They've been coming down to Quartzsite for sixteen years. This is their home and their vehicle; that's a real sense of freedom. But they told me this would probably be their last year because they're having trouble with the driving."

PAGE 73

Walking with grandchildren, La Hacienda RV Park, Apache Junction, Arizona, March 1999

Most La Hacienda retirees are from Minnesota or Iowa. Spring break for schools back home brings children and grandchildren into the community.

PAGE 74

Street party potluck dinner, La Hacienda RV Park, Apache Junction, Arizona, March 1998

Gydesen: "These gated communities in the Phoenix area are tightly controlled. Everyone knows everybody's business, and strangers are pretty obvious. I chose La Hacienda because I knew people there. I still struggle to understand [the RV park phenomenon], but I know it's really about the importance of connections and community and staying active.

"I visited here on the day of their annual country fair, complete with a parade, horse races, and a pie-eating contest. It was here, too, that I learned being retired didn't necessarily mean being over 65. I met Gene Domini, in his late fifties, who took early retirement from the post office to care for his wife. She died last year after a ten-year struggle with Alzheimer's. Now it's just Gene and his disabled thirty-five-year-old daughter making their way from St. Paul to Apache Junction in their Pace Arrow."

PAGE 75

Hiking group from La Hacienda RV Park, Apache Junction, Arizona, March 1999

Gydesen: "I couldn't keep up with these people. They golf five times a week, a lot of them. The hiking group, particularly the men, would take fifteen-to-twenty-mile hikes in the mountains. Half of them would start from one end, half from the other. Then they'd meet in the middle, have lunch, and exchange car keys. At the end of the hike, they'd drive each other's cars back so that nobody had to backtrack."

PAGE 76

The Lundbergs playing golf, Quartzsite, Arizona, January 1999

The Lundbergs of Detroit Lakes entertain friends and family on their homemade golf course in the desert. Each of the nine holes is made from PVC tubing. At the end of every season, they remove the tubing and mark the spot by pounding a big nail in the ground. The next winter they find the hole with a metal detector and resume their games.

PAGE 77

Shirley (Bird) Christianson from Bemidji with her dachshund, Sweetie, Quartzsite, Arizona, January 1999

There are women, like Christianson, who drive alone. She takes Sweetie along for company.

PAGE 79

Lou Gydesen of Inver Grove Heights checking his wife Darlene's blood pressure, Naples, Florida, December 1997

The photographer's parents have been wintering in Florida in their RV since 1989. Maintaining health is a constant concern for snowbirds. If health seriously deteriorates, most return to their northern homes to be with family.

PAGE 80

Sharon Ramberg from Mentor selling Oof-Da Tacos, Quartzsite, Arizona, February 1998

Sharon and her husband, Don, go to Quartzsite every winter to both relax and work. Their taco stand is located in Quartzsite's huge flea market. They sell tacos seven days a week, from morning to night. One secret to their success is using Indian fry bread instead of tortillas.

Gydesen: "Quartzsite has fewer facilities [than La Hacienda]—there's no pool or shuffleboard. But there's the Quartzsite Improvement Association—just a building, really, where they hold bingo, exercise classes, and state dinners, as in the Minnesota dinner, Iowa dinner, etc."

PAGE 81

Jan and Dave Dahl of Winona watching weather news from Minnesota via satellite, Crystal Lake RV Resort, Naples, Florida, December 1997

Gydesen: "Recreational vehicles have changed to cater to an aging population. In the early 1970s, RVs were designed with the family in mind. Today, even though RVs are bigger than ever, they're designed for the comfort of two. To quote my uncle Gus, a retired RVer, 'They're designed to drink six, feed four, and sleep two.'"

DAVID HEBERLEIN
VISITING STATE PARKS

PAGE 84

Rock-climbing class, Interstate Park,
Taylors Falls, July 11, 1998

At Interstate Park Heberlein encountered members of Woodswomen, an outdoor recreation group, practicing their beginners' rock-climbing skills.

Heberlein: "They were doing their best to forget I was there. They didn't want me to take any pictures, didn't want to give me their names. I made my picture and moved on."

PAGE 85

Mother and daughter, Fort Snelling State Park,
St. Paul, February 13, 1999

Beth Rutter, of Deephaven, came to the park to try out the latest in snowshoes during the Winter Trails '99 Snowshoe Festival. This type of high-tech snowshoe, called a Sherpa, is designed for groomed trails, not deep snow.

Heberlein: "Saturday, 13 February, 1999, Fort Snelling SP (98 miles RT) Sunny, upper 20s. Most interesting picture of the day was Beth Rutter with her eight-month-old daughter on her back. This is one of the first vertical-format pictures I've ever made with the 6 x 7. Send family picture to them. And a business card."

PAGE 86

Headwaters of the Mississippi River,
Itasca State Park, Lake Itasca, July 6, 1999

Heberlein: "I went back several times during the three days I was there and it was always like this, packed with people. This is the slippery part—a lot of people don't make it all the way. In the parking lot I looked at license plates and there were a lot of out-of-state cars. I heard French and German . . . it draws a large crowd."

PAGE 87

Weekend camper, William O'Brien State Park,
Marine on St. Croix, July 11, 1999

Heberlein: "He comes up just on the weekends, spreads out newspapers, and reads. He goes to town to eat, doesn't cook. He travels alone. People [I encountered in the parks] who were reading seemed to be mostly from larger cities. Maybe it's a way of bringing home with them. Instead of exploring, they're sitting in it [nature], and that's enough—to be surrounded by it."

PAGE 90

Arriving for a Voyageur Encampment,
William O'Brien State Park, Marine on St. Croix,
September 26, 1998

Heberlein: "Saturday, 26 September 1998, William O'Brien SP and Interstate SP (120 miles RT) Cloudy/rainy, humid, low 70s. Today went to check out the Voyageur Encampment. One group is local, Twin Cities, called La Compagnie des Hivernants de la Rivière St. Pierre. I made a few pictures of the Moline family [Robert, his wife, Jean, and their two-year-old daughter, Miranda]. This is the 8th year they've been coming here. This particular birch bark canoe was constructed around 1988 or 1989 by Mark Hansen from Grand Marais, with a Minnesota Historical Society grant."

PAGE 92

Snake demonstration, Rice Lake State Park,
Owatonna, July 4, 1998

This young camper from Chanhassen was reluctant to hold the fox snake until veteran naturalist Elaine Felkema gave him some advice to calm his fears: "You don't hold the snake, the snake holds you."

PAGE 93

Wading pool, Beaver Creek Valley State Park,
Caledonia, July 25, 1998

Park staff created this pool for visitors who don't want to wade in cold, spring-fed Beaver Creek. But it is seldom used by the hundreds of campers who come to the park every year. So this mother and daughter from Owatonna have a serene place to themselves.

Heberlein: "I looked at some old photos of the park in the 1950s and the hillside behind the wading pool was almost treeless. They've planted the trees."

WING YOUNG HUIE
SMALL-TOWN DIVERSITY

PAGE 96

Boys in the park, Mountain Lake, July 1998

Huie: "These guys were pretty shy. I asked them to come over so I could photograph them. I don't pose people. I may tell them where to stand but not how to arrange themselves because they position themselves with some meaning. For example, the person in the middle is probably always in the middle—it's no accident. Ever since [my project on] Frogtown, I've found myself shooting into the sun. I like the look—the shadows seem to make it more interesting somehow, more romantic. Full-face light can look so harsh."

PAGE 97

Parade watchers at Powwow Festival, Mountain Lake, June 1999

According to the Mountain Lake Chamber of Commerce, this Powwow Festival is the oldest small-town festival in Minnesota. Despite its name, it has nothing to do with American Indian heritage or activities. Its origins are uncertain but reportedly lie with farmers coming to town to weigh their pigs and holding a fat-pig contest.

Huie: "[The mixed audience] was pretty common along the parade route, although there were some pockets here and there—like clusters of Laotions in front of the Lao store."

PAGE 98

Men playing takraw in a park, Butterfield, July 1998

The game of takraw, which originated in Southeast Asia, can best be described as a cross between soccer and volleyball. Players cannot touch the rattan ball with their hands, nor can the ball touch the ground.

PAGE 99

Buddhist ceremony for Laotians, Mountain Lake, April 1998

More than one hundred people from several surrounding towns attended this ceremony at a Mountain Lake home. The participants are "making merit"—preparing themselves and their ancestors for the afterlife—by offering food and money trees to the monks. Afterwards, the monks returned to the Twin Cities and the participants enjoyed an outdoor feast.

Huie: "The monks taste a little from each plate to bless the plate. There was a lot of praying. The man in the white shirt had a microphone—he was a sort of emcee. I remember wishing I had color film because the Orange Crush was the same color as the robes."

PAGE 101

Teenage couple, Mountain Lake, June 1999

Huie: "This was taken at the Powwow Festival. The teen couple—Lao boy and Anglo girl—hadn't been going out very long. They were sort of giggly and he was trying to be real cool so I had to wait around awhile. Eventually I asked him about being a biracial couple, and he was like 'Huh?' He said her parents were really cool,

really nice to him, so there wasn't any feeling, at least for him, of conflict. This was more about first love, I think."

PAGE 102

Firefighter José Cruz Carreon, Jr., St. James, September 1998

Huie characterizes Carreon as "Mr. On-the-Go." A part-time firefighter, he is also an active member of La Roca Pentecostal Church and a soccer and football player.

Huie: "He grew up somewhere in the South and traveled all over with his father when he was younger. They settled in St. James in 1984. His father is a migrant farmworker and also the preacher at La Roca. They have a church activity every night. I often wonder about how, culturally, people pose for pictures. He was just real proud, and that's how he stood."

PAGE 103

Worshipping at La Roca Pentecostal Church, St. James, September 1998

Huie found that the worshippers accepted his presence easily as they concentrated on their prayers and the service.

PAGE 104

Andres Hernandez and his son in their newly purchased home, Mountain Lake, August 1998

Huie: "He was painting his porch, that's how I met him. He really likes his new house. His wife works at the Swift plant during the day so he takes care of the kid, then she takes care of the kid at night while he's working. He seems pretty content."

MARK JENSEN
INDEPENDENT BUSINESSES

PAGES 108, 109

Mel's Fish, Knife River, August 27, 1997

Mel's has been selling smoked fish to North Shore visitors since the 1920s.

Jensen: "When you take an exterior, it's nice to know what the back room looks like, too. Their back room is the smokehouse. They say Ethel can outwork anyone. There's a map of the world on which they invite customers to locate their hometowns. They get a lot of traffic from all over, located as they are in the heart of North Shore tourism."

PAGE 110

Charles D. Stately, Woodland Indian Crafts, American Indian Center, Minneapolis, September 15, 1998

Jensen: "His grandfather started the business. He [Stately] also works as a distributor of jewelry and related things. He sells beads, too, and is a major supplier for people who do beadwork. Most of the items he sells have been made in the Ojibwe style, though he also has a bit of stuff from the Southwest. This is a small place, one of the smallest I photographed."

PAGE 111

Fang Keu and Sao X. Vang, truck farmers from Hugo, at the Minneapolis Farmers Market, August 1998

Jensen: "[This woman and her son] didn't mind being photographed. It really helped to have the letter [from the Minnesota Historical Society, explaining the MINNESOTA 2000 project]. People were able to see that I was working on a historical project of some importance. Often I left my camera in the car at first and went in and explained what I was doing. I think I was turned down only once. I probably spent at least a half-hour with everyone, often more. Didn't have much chance to talk to these folks because of the traffic there. The crowd was tremendous."

PAGE 112

Lauren and Bill Weckman, Tom's Logging Camp, North Shore Drive, Duluth, October 26, 1997

Jensen: "This is a place for tourists to go on a self-guided tour through a miniature logging camp—cook shack, bunkhouse, etc. Belonged to Lauren's father. The theme is logging but the gift shop also sells mementos of Minnesota. Not all made in Minnesota, more of an 'up north' feeling."

PAGE 113

Al Hagen, Yesterday's Autos, Minneapolis, August 1998

Jensen: "I saw a lot of shops devoted to reselling older things. Al does appraisals, sells the cars, and takes a percentage. He also owns the building. I photographed this place as an example of reuse, collectibles, and [the omnipresence of] the auto."

PAGE 114

John, holding Harry, Stephanie, and Katherine Park, holding Gabriell, First Oriental Grocery, Duluth, September 1998

Korean-American owners John and Katherine Park spend long days at this family business. To help pass the time and keep the family together, they installed a play loft for their children in the back of the store. Many Asian markets begin by serving the Asian community but some become more widely popular, as this one has, serving Duluthians since 1983.

PAGE 116

Tony Jerman, Sindbad Cafe and Market, Minneapolis, September 1998

Jensen: "He's making pocket bread. He wanted me to record what he was working on so he put the bread back in the oven to stage a photo of removing it. It was very warm in there. This bakery mostly supplies other restaurants."

PAGE 117

Sami Rasouli, Sindbad Cafe and Market, Minneapolis, September 1998

Jensen: "This is the front part of the store— it's a Middle Eastern market, with a blend of Mediterranean foods. They sell other things too—pipes, rugs, art. There were lots of people shopping in here the whole time I was shooting—people the proprietor seemed to know. Very friendly place—he says he wants to make people feel at home."

PETER LATNER
MAIN STREET

Subject specialist Susan Granger's suggestions of towns for Latner to visit were graded by population: "tiny places" (under 1,000); "small towns" (1,000–5,000); and "larger towns" (5,000 and over). Population figures here are from the 1990 census or newer estimates.

PAGE 120
View from courthouse lawn, Preston, November 29, 1997

Population 1,530
Latner: "This was one of the few towns [I visited] built on the more Southern style of the courthouse square, surrounded by four commercial streets—a very handsome design. It was late Saturday afternoon so there's not much going on."

PAGE 121
Outskirts, Owatonna, September 14, 1997

Population 19,600
Latner: "What drew me to this scene was the sidewalk sale set up outside the store. The irony was too rich for me to pass up. If there's any business that's about our automobile culture, it's Wal-Mart—and here they're making this little 'sidewalk' at the edge of their parking lot."

PAGE 123
Outskirts along U.S. Highway 10, Perham, April 4, 1998

Population 2,075
Latner: "This sort of architecture is designed for cars, for people driving past. These are the new main streets, 'travelers' streets' as opposed to residential streets. There's nothing at all about pedestrians here, and it's very generic. Could be Nebraska, could be Montana."

PAGE 124
Atlantic Avenue, Morris, September 16, 1997

Population 5,613
Latner: "Morris was on a railroad route and the tracks went right through the center of town. There were then two main streets, Atlantic and Pacific avenues—they ran down either side of the tracks. This little mall [built in 1980] is one of those 'built to save the downtown' malls."

PAGE 125
Main Street on Saturday morning, Detroit Lakes, April 4, 1998

Population 6,635
This busy main street in Detroit Lakes impressed Latner because it contrasted so sharply with some others he visited. Its success is due to the town's location in a lake-filled recreation region and to its role as a regional center and county seat of Becker County. Notice the sign welcoming snowbirds back home.

PAGE 126
Barbershop, Ortonville, September 17, 1997

Population 2,205
Latner: "I was passing by and noticed all the guns in the window. It was closed, so I came back later and I was feeling a little shy so I got a haircut first. It was the fastest haircut I've ever had—took less than five minutes. The barber, Duane, collects guns. He had more than he knew what to do with so most of these have price tags on them. I like barbershop banter— they talk about how lazy they are, and 'when are you gonna get a real job.' The guy in the corner was named Floyd, I think—you just sort of knew he spent a lot of time hanging out there. I saw many of these old barbershops on main streets, and most are still open. Still a steady trade. I think these will be among the last businesses to go, when the old guys retire."

PAGE 127
Teens on Main Street on a summer evening, Walker, June 30, 1998

Population 950
Latner: "A lot of activity here in Walker— tourist-oriented businesses serving the resorts on Leech Lake nearby. These kids were really excited about being photographed for the Historical Society. Third from the right is a girl, the rest are boys—just kids on a summer night, looking for something to do. I saw them later in the bank parking lot, practicing tricks with their skateboards. Nothing much changes, except the hairstyles."

PAGE 128
Wheaton, August 31, 1997

Population 1,615
Latner: "This is close to being a favorite image of mine. I was really happy to have stumbled on it. I like the contrast between the bank, the once-grand town institution that's now a makeshift office building, and the gazebo. The gazebo is actually part of a new drive-in bank in the shadow of the old bank. No one is likely to use it—it's kind of a sentimental throwback to the idea of what small-town life was supposed to be at the turn of the last century. This image is an elegy for a way of life that's not around anymore."

PAGE 129
Little Falls, July 1, 1998

Population 7,232
Latner: "Little Falls is bisected by the Mississippi River. There are two commercial districts; this was off Main Street. The scene [painted in 1991 by Frank Grosiak, a native of Little Falls] has the same flavor as the gazebo in Wheaton— that same sentimentality. There was a business there once, under the mural; you can see the outline of the old door and windows."

DAVID PARKER
INDUSTRIAL LABOR

PAGE 132
Packing hamburger patties, GFI America, Minneapolis, August 1998

At GFI in south Minneapolis, thirty to fifty tons of beef are processed daily. Many of its employees are recent immigrants from Southeast Asia and Mexico. The average temperature in the plant is 45 degrees, and employees are required to wear gloves, hairnets, and hard hats.

PAGE 133
Operating a pouring ladle, Acme Foundry, Minneapolis, July 1998

Parker: "I went to Acme because it's near my house [in the Longfellow neighborhood of south Minneapolis]. It's just a little neighborhood foundry—really old. And it's not just the foundry that's old—the process itself is ancient. They still make molds, mostly out of sand; they still pour the hot metal into the sand; and they still smash it apart at the end. On the other hand, the furnaces that melt the steel use very twenty-first-century technology."

PAGE 134
Workers on lunch break, Toro Assembly Plant, Windom, February 1999

Parker was surprised to see how often people spent their lunch time on the factory floor next to their work stations. "It's like home," he says.

PAGE 135
Jaime Herrera in the chili room, GFI America, Minneapolis, August 1998

Parker: "Those things on the left are chili cookers, where they dump big bags of chili and meat and hamburger. Then they empty the stuff into the plastic-lined garbage buckets. Mr. Herrera was mainly in charge of cleaning. It's a very wet process. They hose the floor so he wears plastic gloves and big rubber boots."

PAGE 136
Caroline Schultz, twenty-nine-year Toro employee, on the Toro Assembly Plant paint line, Windom, February 1999

Parker: "The paint department here is very technologically advanced. You can see all the lawnmower parts hanging on racks. They're run through paint booths where electrostatically charged paint is sprayed on to create a molecular layer of paint. Unlike older factories, where the people might get covered in paint, these places can be immaculate. This woman runs the machines that paint the parts; she makes sure the paint is flowing properly and the parts are coming in. Though the machines are mechanized, they require some degree of monitoring."

PAGE 138
Injured worker adjusting machine, Smith Foundry, Minneapolis, May 1998

Parker: "For a lot of people doing these types of jobs, a day without work may be a day without adequate food. And the workers compensation system, in my own editorial opinion, tends to be inadequate. There's a tremendous push among employers to put people to work, even if they're injured. It's just like with football players but instead of getting a million dollars a game, you get ten bucks an hour.

"This guy is sitting on the edge of a furnace trying to get an electromagnetic induction coil aligned. He's holding a control device that moves the bucket up and down. The furnace is about eight feet deep and there's only one-thousandth of an inch tolerance from top and bottom. It's fairly complicated. The foundry was shut down that day because when they're fixing the bucket, you can't pour."

PAGE 139
Using a grinder to finish parts, Smith Foundry, Minneapolis, June 1998

Parker: "When the parts come out of the molds, they have edges on them. He's using a high-speed metal sander, a buffer, to take the edges off. I believe he has a whole separate air system [inside his suit]. The fan cools him down. These places have a lot of fans to keep the air moving."

PAGE 140
Pouring steel, Smith Foundry, Minneapolis, July 1998

These men are pouring molten steel heated to 1,800 degrees. At his clinic, Parker once treated someone who accidentally had some dropped into his boot. "Horrible injuries," says Parker. Most workers wear cotton clothing and heavy overalls, with some type of asbestos gloves; synthetic fabrics would melt at such high temperatures. It's hot in the foundry so workers can't pile on clothing. "They have to strike a balance between the risk of injury and how much heat they can tolerate," he says.

PAGE 141
Woman on break, Acme Foundry, Minneapolis, July 1998

Most Acme employees come from the nearby Longfellow and Phillips neighborhoods. Even though the temperature that summer day was 97 degrees, this woman was sitting outside to escape the heat inside the foundry. When Parker went back a week later to talk to her, she was gone—laid off.

KERI PICKETT
TEENAGERS

PAGE 144

Couple dancing, Young Life dance on a Mississippi River paddleboat, Minneapolis, October 1998

Pickett: "Even though this was a church function and a church crowd, the level of sexual energy there was hardly church mouse. You could see the variety of relationships by how people danced, with some people looking kind of disconnected and empty, like I think this woman is."

PAGE 145

Teenager working gate entrance at Minnesota State Fair, Falcon Heights, August 1998

Pickett: "I went to the State Fair because, when I was a teenager, the fair was a major social event. It had layers of excitement, with the rides, and meeting boys, and flirting, and sparking love relationships. I was in 4-H as a teen, and I used to get ribbons for my jams and jellies and sewing. The fair was part of my development. This isn't the most glamorous job at the fair. He's in a very public position—he has to talk to everyone coming in—but he's still got his Walkman on."

PAGE 146

Homeless teens playing pool at Sharing and Caring Hands, Minneapolis, April 1999

These girls are in the Teen Center of Mary's Place, a transitional housing facility. It's part of Sharing and Caring Hands, a social services agency founded by Mary Jo Copeland in 1985.

Pickett: "In this picture is one of my favorite sayings: 'What you are is God's gift to you. What you become is your gift to God.' I like the way the picture lined up so the two fingers are tapping her on the shoulder."

PAGE 148

Brothers learning automotive repair at Newgate School, Minneapolis, May 1999

Charkone and Tseknue Moua are just beginning a two-year course in automotive maintenance and repair at Newgate, a vocational school that teaches job skills to economically disadvantaged youth.

PAGE 149

Eagle Scout and merit badge ceremony, Bethlehem Lutheran Church, St. Cloud, October 1998

Pickett: "This was a world I didn't know about at all as a teenager. So it was a great gift to see these Boy Scouts stand up and relate their experiences in front of a group. Some were very articulate. The blond young man in the center of the picture became an Eagle Scout that night. He is just radiating goodness, sitting with his spine perfectly aligned, eager, looking forward. I think people have natural gang tendencies and this is one aspect of clustering together—learning, playing, working toward individual goals but doing it under a collective umbrella where everybody understands the rules."

PAGE 150

Cicilia Loom, playing Clara, during dress rehearsal of The Nutcracker, *Stillwater, November 1998*

Pickett: "I wanted to include a teen involved in politics. I met Cicilia at a protest rally against Alliant Technologies; they make parts for land mines. She and her younger brother had decided to go. Their mother was with them but she wasn't comfortable with the fact that they wanted to get arrested. I found out later that she did get arrested after I left. So I talked to her again and asked about some of her other interests. She has very strong ambitions to be a professional ballet dancer. She's very talented . . . and very independent-minded."

PAGE 151

Jill Adams, 16, as "Pedro" at District 202 tent, Pride Festival, Minneapolis, June 1999

Adams and her friends from District 202, a Minneapolis center for gay teens, raised money for the center by selling hugs for a quarter apiece at the Pride Festival, held annually in Loring Park. Her disguise played with perceptions of gender roles and gave her the confidence to act flamboyantly for the sake of fund-raising.

PAGE 152

Teens at Theodore Wirth Park to celebrate the birthday of the Dalai Lama, Minneapolis, July 1998

Pickett: "Minnesota has the largest Tibetan resettlement community in the United States outside New York. I've been documenting one woman's life in that community for the last five years so I would have been at the event anyway. But this year I focused on the teenagers. These kids are very savvy, very hip—as soon as they're out of their traditional dance outfits, they're in their teenager clothes. These two are listening to a CD player together—he has one earpiece and she's got the other. It was part of their flirting."

PAGE 153

Heather Kennelly, 18, and Stephen Daniel, 16, on a walk near Wolf Lake, August 1998

Pickett: "Stephen and Heather were getting to know each other that summer—it was a new experience for Stephen. I saw them heading down that path at sunset and I thought about my grandparents [the subjects of Pickett's book *Love in the 90s*] and about taking the road together with a life partner. In their body language you can see a hesitation, an inwardness. They're both tilting out, as if there's a little bit of apprehension, almost a fear of each other. That's understandable when you're just starting a new, adult life."

THE PHOTOGRAPHERS

JOSEPH ALLEN

Born Eagle Butte, South Dakota, 1964

Joseph Allen is something of a Renaissance man. Since 1995 he has been a photographer, writer, editor, and designer at *The Circle*, a Twin Cities American Indian community newspaper; he currently serves as its managing editor. Of Lakota and Ojibwe/French descent, Allen moved to Minnesota in 1984. He has photographed Indian communities here since 1991 and, through his work at *The Circle*, has developed contacts with Indian organizations and individuals throughout the state. Allen won first place in the "Photo Shoot-out" sponsored by the *New York Times* at the 1996 Native American Journalists Association Conference in Bangor, Maine.

SELECTED EXHIBITIONS, PUBLICATIONS, AND HONORS

Four Seasons of Corn, Lerner Publications, 1996.

McKnight Foundation Photography Fellowship, 1993.

THOMAS ARNDT

Born Minneapolis, Minnesota, 1944

Calling himself a "picture-taking machine," Thomas Arndt has photographed the people and places of America for more than twenty-five years. His subjects are varied: farm families, Chicagoans, the homeless, American men, Holocaust survivors, and, now, Minnesota's famed lakes and rivers—specifically, the people in and around them. Based in Chicago since 1989, Arndt was exhilarated to rediscover Minnesota's open spaces and soft, silvery light. His nationally renowned work has garnered him many fellowships and commissions and has appeared in numerous publications. Arndt's photographs are included in the permanent collections of such institutions as the Museum of Modern Art in New York, the Art Institute of Chicago, and the George Eastman House in Rochester, New York.

SELECTED EXHIBITIONS, PUBLICATIONS, AND HONORS

A City Called Heaven: Photographs of Chicago by Tom Arndt, Wright Museum of Art, Beloit College, Beloit, Wisconsin, 1999.

Democratic Processes: American People and Politics, pARTs Photographic Arts, Minneapolis, 1996 (group exhibition, catalog). Traveled to Hartnett Gallery, University of Rochester, Rochester, New York, 1997.

Crossing the Frontier, San Francisco Museum of Modern Art, 1996 (group exhibition, catalog).

Chicagoland: Recent Work by Tom Arndt, Minneapolis College of Art and Design, 1993 (catalog).

Men in America, Art Institute of Chicago, 1992.

Tom Arndt's America, Minneapolis Institute of Arts, 1984.

Men in America, National Museum of American Art/D.A.P., 1995.

Text by Ellen A. Miller
Portraits by Eric Mortenson

STEPHEN DAHL

Born Frederick, Wisconsin, 1953

By day Stephen Dahl is a social worker, a profession that has had a significant impact on his photographic outlook. Since 1992 he has documented a cross section of workers in Minnesota's service and manufacturing industries, focusing on people who work behind the scenes to clean hotel rooms, stock shelves at discount stores, or inspect circuit boards. "These people work hard every day, and we seldom notice them," says Dahl. For the photographer, his pictures are not so much about work as they are "about how people sustain themselves and get through the day."

SELECTED EXHIBITIONS, PUBLICATIONS, AND HONORS

Working, pARTs Photographic Arts, Minneapolis, 1999 (catalog).
Face Value: In Pursuit of the Person, Minneapolis College of Art and Design, 1998 (group exhibition).
Minnesota Works: Photographs by Stephen Dahl, Governor's Mansion, St. Paul, Minnesota, 1993.

pARTs Journal, Summer 1997.

McKnight Foundation Photography Fellowships, 1988, 1994.
Minnesota State Arts Board Fellowships, 1992, 1996.
National Endowment for the Arts Grant, 1990.

CHRIS FAUST

Born Fort Riley, Kansas, 1955

Since 1994 Chris Faust has collaborated with landscape architect Frank Edgerton Martin on the Suburban Documentation Project (SDP). A nonprofit organization guided by urban planners and historians, the SDP tracks the growth of American suburbs. Faust and Martin are concerned about the sameness and rootlessness that mark today's suburbs. They hope, Martin writes, that their work raises the question, "Is there not a better way?" With its large collection of images and related materials such as marketing brochures and homeowners' association bylaws, SDP also is intended to serve as an archive for future historians. Faust's tool of choice for his work photographing landscape change is a Fuji G617 panoramic range-finder camera. He started using it in 1988, and "now I see the world that way. It would be hard to go back to the 35mm camera."

SELECTED EXHIBITIONS, PUBLICATIONS, AND HONORS

Land Used, Carleton College Art Gallery, Northfield, Minnesota, 1998 (group exhibition).
Metroscapes: Suburban Landscape Photography of the Twin Cities and Beyond, Weisman Art Museum, Minneapolis, 1998 (group exhibition, catalog).
Crossing the Frontier, San Francisco Museum of Modern Art, 1996 (group exhibition, catalog).
Landscape Photography, Phipps Center for the Arts, Hudson, Wisconsin, 1993 (group exhibition).

Minnesota Monthly, March 1997.
Design Book Review, Fall 1992.
Design Quarterly, Summer 1992.

Bush Foundation Artist Fellowship, 1995.
McKnight Foundation Photography Fellowships, 1989, 1992, 1997.
Minnesota Humanities Commission Grant, 1995.
Minnesota State Arts Board Fellowship, 1994.

GEORGE BYRON GRIFFITHS

Born Beeville, Texas, 1971

George Byron Griffiths, or Geordie, as he is known, comes from a family of artists, educators, and storytellers. So it's no surprise that he uses photography as a storytelling vehicle. He is partial to documentary photographs because they "capture moments of human life and reveal themselves as time passes." From 1994 to 1997, while working as a teacher's aide in special education at the Cuyuna Range Elementary School in Crosby, Minnesota, Griffiths photographed some of the children there. With a grant, he produced an exhibit of those images. He continues to photograph three of the children, aiming to document the "incredible lives they lead and to celebrate the range of relationships, emotions, struggles, and triumphs that are part of their life experiences." Since 1997 Griffiths has worked as an assistant to photographer Keri Pickett and teaches photography at the Edina Art Center, Edina, Minnesota.

SELECTED EXHIBITIONS, PUBLICATIONS, AND HONORS

Harmony of God: Photographs and Text by George Byron Griffiths, Benedicta Arts Center, College of St. Benedict, St. Joseph, Minnesota, 1998.

Five Wings Arts Program/McKnight Foundation Grant, 1996.

TERRY GYDESEN

Born Minneapolis, Minnesota, 1955

Freelance photographer Terry Gydesen's usual beat is the American political scene. Her interest in politics was sparked by her experiences as staff photographer for Jesse Jackson's 1988 presidential campaign. She went on to chronicle the presidential campaigns of 1992 and 1996. Her political photographs are both playful and perceptive. "I seek images that are like a puzzle," she says. "I provide enough visual information to engage the viewer instantly, then add subtle details for lasting intrigue." Several of her photo essays have appeared in *City Pages*, a weekly Twin Cities newspaper. Gydesen has taught at Carleton College in Northfield, Minnesota, and the Minneapolis College of Art and Design, among other Upper Midwestern schools.

SELECTED EXHIBITIONS, PUBLICATIONS, AND HONORS

Art, Law, and Politics, Kellie Rae Theiss Gallery, Minneapolis, 1999.
Democratic Processes: American People and Politics, pARTs Photographic Arts, Minneapolis, 1996 (group exhibition, catalog). Traveled to Hartnett Gallery, University of Rochester, Rochester, New York, 1997.
People—Places—Politics, pARTs Photographic Arts, Minneapolis, 1995 (with Peter Latner).

Prince Presents the Sacrifice of Victor: Photography by Terry Gydesen, Paisley Park Enterprises, 1994.

McKnight Foundation Photography Fellowships, 1989, 1992.
Minnesota State Arts Board Fellowship, 1996.

DAVID HEBERLEIN

Born Fennimore, Wisconsin, 1949

For David Heberlein, documenting Minnesota's state parks tapped a vein of childhood memories. "Some of my most vivid memories are from summer vacations," Heberlein says. "We were a typical middle-class, Midwestern family, piling into a loaded station wagon for a quick drive through a national park or two, stopping briefly to take a family picture that documented our presence there. My dad called it taking a 'windshield inventory.'" This snap-and-run approach fueled Heberlein's interest in how visitors interact with the park landscape. Since 1990 he has been photographing tourists at a variety of national parks and monuments. That work sparked an interest in the tension between promotion of these popular destinations and ongoing efforts to protect their natural resources. Heberlein is an associate professor of photography at the University of Wisconsin, River Falls.

SELECTED EXHIBITIONS, PUBLICATIONS, AND HONORS

Metroscapes: Suburban Landscape Photography of the Twin Cities and Beyond, Weisman Art Museum, Minneapolis, 1998 (group exhibition, catalog).

Mississippi-Neva: An Exhibition of Contemporary American Photographs, The State Russian Museum, Stroganov Palace, St. Petersburg, Russia, 1998 (group exhibition).

Wisconsin at 150 Years: Sesquicentennial Rephotographic Project, State Historical Society of Wisconsin Museum, Madison, Wisconsin, 1998 (group exhibition, catalog).

Landscape Photography, Phipps Center for the Arts, Hudson, Wisconsin, 1993 (group exhibition).

State Historical Society of Wisconsin Grant, 1997.
Wisconsin Arts Board Grant, 1993.

WING YOUNG HUIE

Born Duluth, Minnesota, 1955

Wing Young Huie knows what it's like to grow up as a person of color in overwhelmingly white surroundings: "We were the only Chinese family in the neighborhood, and I was the only Asian kid in my school until the tenth grade." In the early 1990s, Huie hit upon the idea of photographing St. Paul's Frogtown, a neighborhood with a diverse racial and ethnic mix. "I was intrigued," he writes, "by . . . what kinds of interaction, or lack of it, were going on among people of disparate backgrounds who . . . lived next door to each other." He spent two years photographing and interviewing residents, who came to know him as the "picture man." In the spring of 1995, on a vacant lot in Frogtown, he mounted an exhibit of 173 photographs, some accompanied by quotes from his interviews. The work was published the next year by the Minnesota Historical Society. Walker Art Center recently featured selections from his latest endeavor, "Lake Street Project, 1996–1999."

SELECTED EXHIBITIONS, PUBLICATIONS, AND HONORS

Dialogues: Paul Beatty/Wing Young Huie, Walker Art Center, Minneapolis, 1999 (catalog).

Unfinished History, Walker Art Center, 1998 (group exhibition, catalog).

Face Value: In Pursuit of the Person, Minneapolis College of Art and Design, 1998 (group exhibition).

Rivers Merging, Minneapolis Institute of Arts, 1995 (in collaboration with playwright/actor Kim Hines).

Frogtown: Photographs and Conversations in an Urban Neighborhood, Minnesota Historical Society Press, 1996.

Minnesota Monthly, November 1995.

Bush Foundation Artist Fellowship, 1996.
McKnight Foundation Photography Fellowships, 1994, 1999.
Minnesota State Arts Board Grant, 1994.

MARK JENSEN

Born Minneapolis, Minnesota, 1945

Mark Jensen has been photographing independent store owners in Minnesota and Wisconsin since 1969. His body of work demonstrates vividly that, contrary to public opinion, the neighborhood store is not dying, it's just changing. What was once the town pharmacy, for example, may now be a dress shop or an Asian market. During thirty years of documenting small businesses, Jensen has noticed other shifts, too—the proliferation of franchise stores and large one-stop-shopping discount emporia. "There are different attitudes now about what's important," he observes. "People used to spend time to save money. Now they spend money to save time." Jensen's work is represented in numerous public and private collections. An educator and artist, he is also publisher and editor of *Photo Notes*, a quarterly journal he established in 1982.

SELECTED EXHIBITIONS, PUBLICATIONS, AND HONORS

Mississippi-Neva: An Exhibition of Contemporary American Photographs, The
 State Russian Museum, Stroganov Palace, St. Petersburg, Russia, 1998
 (group exhibition).
Center for Creative Studies, Detroit, Michigan, 1985.
Minnesota Invitational, Minneapolis Institute of Arts, 1975 (group exhibition).
Madison Art Center, Madison, Wisconsin, 1974.

pARTs Journal, March 1996.

Minnesota State Arts Board Grants, 1987, 1997.

PETER LATNER

Born New York, New York, 1950

Peter Latner has long been beguiled by Minnesota's small towns. His work centers on celebrations and festivals throughout the state, with parades and other public events holding a special fascination. "The popular image of the small town in the twentieth century has largely been formed by Sinclair Lewis and Walt Disney," says Latner. "The result: these places are too often seen either as dens of conformity and pettiness or havens of lost innocence." Latner has taught photography at the Minneapolis College of Art and Design and other schools; he currently serves as museum collections photographer at the Minnesota Historical Society.

SELECTED EXHIBITIONS, PUBLICATIONS, AND HONORS

Metroscapes: Suburban Landscape Photography of the Twin Cities and Beyond,
 Weisman Art Museum, Minneapolis, 1998 (group exhibition, catalog).
People—Places—Politics, pARTs Photographic Arts, Minneapolis, 1995
 (with Terry Gydesen).
Automotive Minnesota, pARTs Photographic Arts, Minneapolis, 1993 (group
 exhibition).
At a Close Range: Minnesota Portraits 1984–1990, Minnesota Historical Society,
 St. Paul, 1991 (with James Crnkovich).

Jerome Foundation Emerging Artists Fellowship, 1985.
McKnight Foundation Photography Fellowships, 1982, 1985.
Minnesota State Arts Board Fellowship, 1986.
Society for Contemporary Photography Fellowship, 1988.

DAVID L. PARKER, M.D.

Born New York, New York, 1951

David Parker is both physician and photographer. As a physician, he sees firsthand the effects of working in unhealthy environments. Through his photography, he has drawn attention to the plight of workers in settings roaring hot or freezing cold, where lighting is poor and breaks are regulated by time clocks. Since 1994 Parker has traveled to South America, Asia, and the Indian subcontinent, photographing child laborers and studying the conditions in which they work. In a 1999 exhibit at the Minneapolis Institute of Arts, his pictures were paired with photographs from the early 1900s by Lewis Hine, who exposed the evils of American child labor. Parker and his advisor on the MINNESOTA 2000 project, labor historian Peter Rachleff, are collaborating on a book about industrial workers, tentatively titled *By These Hands*.

SELECTED EXHIBITIONS, PUBLICATIONS, AND HONORS

Help Wanted: Child Labor Photography by Lewis Hine and David L. Parker,
 Minneapolis Institute of Arts, 1999.
Lowell National Historical Park, Lowell, Massachusetts, 1997.
U.S. Senate Rotunda, Washington, D.C., 1997.
Stolen Dreams: Portraits of Working Children, Minneapolis Photographers
 Gallery, 1994.

Labor's Heritage, Summer 1994.
Minnesota Medicine, July 1997.
Stolen Dreams: Portraits of Working Children, Lerner Publications, 1997.

McKnight Foundation Photography Fellowship, 1994.

KERI PICKETT

Born Charleston, South Carolina, 1959

Photo-essayist Keri Pickett is a regular contributor to *People* and other national magazines. The themes of love, family, and community-building are central to her projects. "I use a reportage style," she says, "photographing people going through their daily lives." Pickett is best known for a photographic study of her grandparents, published in 1995 as *Love in the 90s*. Her interest in Tibetan culture led her to the Kingdom of Lo in Nepal, where, as one of the first Western photographers to gain access to the region, she began her series of Tibetan portraits. Pickett has also produced a photo essay on children with life-threatening illness. A book of her "Faeries" photographs will be published by Aperture in 2000.

SELECTED EXHIBITIONS, PUBLICATIONS, AND HONORS

Love in the 90s, New Orleans Museum of Art, 1998. Also presented at Southeast
 Museum of Photography, Daytona Beach, Florida, 1998; NAFOTO International Photography Festival, São Paulo, Brazil, 1997; Jon Oulman Gallery,
 Minneapolis, 1994.
8 x 10: Contemporary American Photography, Eight Images x Ten Photographers,
 Godwin-Ternbach Museum, Queens College, Flushing, New York, 1996
 (group exhibition).
In the Kingdom of Lo, Minneapolis Photographers Gallery, 1995.

Love in the 90s, B. B. & Jo: The Story of a Lifelong Love, A Granddaughter's Portrait,
 Warner Books, 1995.
Village Voice, January 3, 1995.

American Photography Book Award (*Love in the 90s*), 1996.
Bush Foundation Artist Fellowship, 1992.
McKnight Foundation Photography Fellowships, 1989, 1992, 1997.
Minnesota State Arts Board Grant, 1991.
National Endowment for the Arts Grant, 1990.

SUBJECT SPECIALISTS

Each of the MINNESOTA 2000 photographers was assigned an advisor, selected for his or her expertise in the thematic area chosen by the photographer or in the field of documentary photography. The suggestions and feedback of these subject specialists guided the photographers in their work, filled in gaps, and helped ensure that each project was appropriately representative and timely. Some specialists participated in the final selection of images for the photographer they advised. All were invited to offer comments for the MINNESOTA 2000 project archives. The photographers and their advisers:

Joseph Allen
Urban Indians
WAYNE GUDMUNDSON

David Heberlein
Visiting State Parks
JOEL STEDMAN

Thomas Arndt
By the Lakes
JOHN LINC STEIN

Wing Young Huie
Small-Town Diversity
KAREN S. STETTLER

Stephen Dahl
Telecommunications Workers
MILDA K. HEDBLOM

Mark Jensen
Independent Businesses
DAVID P. BRENNAN

Chris Faust
Along the Minnesota River
JOHN R. BORCHERT

Peter Latner
Main Street
SUSAN GRANGER

George Byron Griffiths
Raising and Educating Children
MARTHA FARRELL ERICKSON

David Parker
Industrial Labor
PETER RACHLEFF

Terry Gydesen
Snowbirds
GERALD A. BLOEDOW

Keri Pickett
Teenagers
ANNE PRELLER

GERALD A. BLOEDOW
Gerald Bloedow retired as executive secretary of the Minnesota Board on Aging in 1994 after twenty-eight years of service. He was founder and past president of the Minnesota Gerontological Society and the National Association of State Units on Aging. Bloedow was also a delegate to the White House Conference on Aging in 1961, 1971, and 1981.

JOHN R. BORCHERT, Ph.D.
John Borchert's forty-year teaching career at the University of Minnesota included stints as chairman of the Department of Geography, associate dean of the Graduate School, and founder and director of the Center for Urban and Regional Affairs (CURA). He was appointed Regents' Professor of Geography in 1981, retiring in 1989. Borchert led the ten-year research and development program that created the state's internationally known Land Management Information System.

DAVID P. BRENNAN, Ph.D.
David Brennan has been associate professor of marketing and director of the Small Business Institute at the University of St. Thomas, St. Paul, since 1987. His areas of expertise are business and marketing planning, market research, service delivery, and retail/service marketing, especially site/location analysis.

MARTHA FARRELL ERICKSON, Ph.D.
Developmental psychologist Martha (Marti) Erickson has been director of the Children, Youth, and Family Consortium at the University of Minnesota since 1991. With Vice President Al Gore, Erickson and the Consortium have co-hosted the Family Policy Conference, a national event held annually since 1994 to address child and family issues.

SUSAN GRANGER
Susan Granger is co-owner of Gemini Research in Morris, Minnesota, which provides historical research, fieldwork, and related historic preservation services to public and private clientele. She is also assistant director of the Historic Sites Survey of St. Paul and Ramsey County.

WAYNE GUDMUNDSON
Photographer and professor Wayne Gudmundson teaches documentary photography at Moorhead State University, Moorhead, Minnesota. Published volumes of his work include *Testaments in Wood: Finnish Log Structures at Embarrass, Minnesota* (Minnesota Historical Society Press, 1991) and *Affinities* (Dacotah Territory Press, 1998). Gudmundson also served as a juror for the MINNESOTA 2000 project.

MILDA K. HEDBLOM, Ph.D., J.D.
Milda Hedblom is a professor of political science and communications at Augsburg College, Minneapolis; a senior associate and adjunct professor at the Hubert H. Humphrey Institute of Public Affairs, University of Minnesota; and visiting professor of telecommunications policy at the Carlson School of Management, University of Minnesota. She is also director of the Telecommunications and Information Society Policy Forum at the Humphrey Institute.

ANNE PRELLER
Anne Preller is a member of the Woodbury High School Class of 2000. As a participant on Woodbury's Youth Advisory Board, she worked to establish culture clubs for minority student groups. She swims on the school team, studies karate, and is active in church. She is also a writer and photographer for *blue jean*, an advertising-free national magazine for teenage girls.

PETER RACHLEFF, Ph.D.
Peter Rachleff has been a professor of labor history at Macalester College, St. Paul, since 1982; he is currently chair of the Department of History. His published works include *Black Labor in Richmond, Virginia, 1865–1890* (University of Illinois Press, 1989) and *Hard-Pressed in the Heartland: The Hormel Strike and the Future of the Labor Movement* (South End Press, 1993).

JOEL STEDMAN
Joel Stedman is interpretive operations coordinator for the Minnesota Department of Natural Resources, Division of Parks and Recreation. As the chief naturalist for Minnesota's state parks since 1992, Stedman oversees program development, interpretive exhibits, and educational materials for all state park visitor centers.

JOHN LINC STEIN
Minnesota native John Linc Stein earned a degree in soil and water resource management from the University of Minnesota. Joining the Minnesota Department of Natural Resources in 1978, he worked as a hydrologist and currently serves as administrator for Permitting and Land Use for the department's Division of Waters.

KAREN S. STETTLER
Karen Stettler serves as community education director for the city of St. Charles, Minnesota, working with Laotian, Hmong, and Hispanic families to build bridges between newer residents and the community. She is also an advisor for at-risk youth in St. Charles. Previously, Stettler served two years with the Peace Corps in Thailand.

ACKNOWLEDGMENTS

The MINNESOTA 2000 Documentary Photography Project has been fortunate in its evolution. From its origins as a conversation piece in the fall of 1994, to its incorporation as an official, full-fledged Minnesota Historical Society undertaking, to its present form in this book and as an archive at the Minnesota History Center, the project has received support from a steady stream of believers.

The first meetings were held in the St. Paul Lowertown studios of Craig Thiesen and Chris Faust, who with Bonnie Wilson, Rob Silberman, and George Slade began shaping this record of Minnesota at the turn of the millennium. Foremost among those who helped flesh out the concept and, most important, provided the photographer's perspective were Terry Gydesen, Kate Maxwell Williams, Ruth Appelhof, and Wayne Gudmundson.

The project's test run came in June 1995 when fifty photographers from around Minnesota convened at the History Center to hear about the project and show their current work. The quality and range of photography presented that day and the enthusiastic feedback from the photographers gave the project an invigorating kick start. Nine of the project's twelve commissioned photographers attended that meeting. We are grateful to all who were present that day; your spirit is borne out in the project's final selection of images.

MINNESOTA 2000 became happily situated at the Historical Society in 1996 when director Nina Archabal and assistant director Lila Goff approved the Society's adoption of the project. Generous support came from Alfred and Ingrid Lenz Harrison, John and Ruth Huss, Robert J. and Sarah-Maud W. Sivertsen, and the Patrick and Aimee Butler Family Foundation.

To select twelve photographers for the project, we used the expert jurying services of Christian Peterson, associate curator of photography at the Minneapolis Institute of Arts; Jim Dozier, former director of the exhibition program at Film in the Cities and the University of Minnesota/McKnight Foundation Artist Fellowships for Photographers Program; Jean Brookins, then the Society's assistant director for Publications and

Research; Wayne Gudmundson, photographer and professor of mass communications at Moorhead State University; and Chicago-based historian and curator Larry Viskochil, whose experience guiding the enormous Changing Chicago documentary project helped MINNESOTA 2000 in many ways.

Besides the directors and development officers Mark Haidet and Ames Sheldon, many other people at the Minnesota Historical Society contributed to the success of this project. In the Acquisitions and Curatorial Department, Valerie Brown, Lori Williamson, and Ann Christensen gracefully accommodated an endless assortment of requests. Assistant director for museums Maureen Otwell, associate curator Ellen A. Miller, and designer Therese Scheller were strong allies in bringing the project into focus for the exhibition *Minnesota 2000: A Photo Documentary for the Future*, curated by Bonnie Wilson and held at the Minnesota History Center from January through June 2000. The text of the exhibit labels, many of which appear as part of this publication's "Notes on the Photographs," were written by Wilson and Miller with assistance from Brian Horrigan; Miller wrote the photographers' biographies.

At the Minnesota Historical Society Press, thanks are due to director Gregory M. Britton, managing editor Ann Regan, and designer Will Powers for their efforts in making this book a reality. Mary Ann Nord skillfully handled the bulk of the editing duties. Phil Freshman graciously offered his own close reading of the manuscript.

Contributors to the Book

GEORGE SLADE of St. Paul is a photography historian who advises and contributes to a wide range of photography projects and publications. He is director of the University of Minnesota/McKnight Foundation Artist Fellowships for Photographers Program and founding editor of the *pARTs Journal*, published by pARTs Photographic Arts in Minneapolis.

ROBERT SILBERMAN is associate professor of art history at the University of Minnesota, where he regularly teaches a course on the history of photography. He served as senior consultant for the KTCA/PBS series *American Photography: A Century of Images*, and, with Vicki Goldberg, co-authored the companion book of the same title. He writes on photography, film, and contemporary art for a wide range of publications.

BONNIE G. WILSON, curator of sound and visual collections at the Minnesota Historical Society, served as project director for MINNESOTA 2000. Since 1976 she has collected thousands of historical photographs for the Society and created its fine art photography collection. She writes and lectures on photo preservation and history, is active in the Association of Moving Image Archivists, and serves on the board of pARTs Photographic Arts.

NEGATIVE NUMBERS

Prints for noncommercial use of the photographs reproduced in this book
may be ordered by negative number through the Minnesota Historical Society's
Order Desk at (651) 297-4706. Other MINNESOTA 2000 photographs and their
negative numbers are available online at www.mnhs.org/minn 2000.

page	negative number	page	negative number	page	negative number	page	negative number	page	negative number
12	84315	40	84356	68	84302	98	84376	126	79366
13	84313	41	84358	69	84300	99	84262	127	79367
14	84318	42	85235	72	85207	100	85160	128	79370
15	84317	43	84354	73	86061	101	84375	129	79371
16	84322	44	85219	74	86062	102	84371	132	84297
17	84319	45	85218	75	86063	103	84372	133	84679
18	84622	48	84324	76	86064	104	84374	134	84309
19	84634	49	84328	77	85206	105	85159	135	84681
20	84269	50	84289	78	79460	108	79781	136	84320
21	84316	51	84261	79	79462	109L	79788	137	84674
24	84366	52	84290	80	86065	109R	79791	138	84308
25	84263	53	84291	81	84258	110	79786	139	84672
26	84361	54	85241	84	84293	111	79796	140	84296
27	84365	55	85255	85	84266	112	79779	141	84307
28	84364	56	85245	86	84337	113	79799	144	84694
29	84362	57	84326	87	85144	114	79801	145	84683
30	85189	60	84301	88	84342	115	79794	146	84348
31	84367	61	84306	89	84591	116	79797	147	84344
32	85188	62	84642	90	85145	117	79777	148	84347
33	85187	63	84643	91	84336	120	79365	149	84343
36	84352	64	84644	92	84338	121	79354	150	85134
37	84355	65	84268	93	84294	122	79367	151	84345
38	85236	66	84305	96	84378	123	79361	152	84346
39	84359	67	84638	97	84377	124	79348	153	84351
						125	79347		

INDEX OF LOCATIONS PHOTOGRAPHED

Minnesota locations pictured in *Minnesota in Our Time* are shown here. The entire MINNESOTA 2000 photograph collection, only one-third of which is reproduced in this book, includes images of many sites not found on the map.

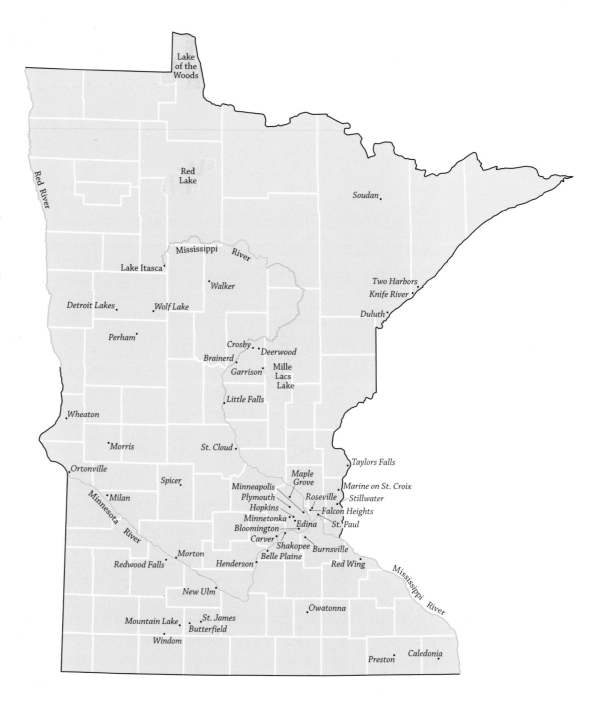

Minnesota locations pictured:

Belle Plaine
Faust

Bloomington
Faust

Brainerd
Griffiths

Burnsville
Faust

Butterfield
Huie

Caledonia
Heberlein

Carver
Faust

Crosby
Griffiths

Deerwood
Griffiths

Detroit Lakes
Latner

Duluth
Jensen

Edina
Griffiths

Falcon Heights
Pickett

Garrison
Arndt

Henderson
Latner

Hopkins
Dahl

Knife River
Jensen

Lake Itasca
Heberlein

Little Falls
Latner

Maple Grove
Dahl

Marine on St. Croix
Heberlein

Milan
Faust

Mille Lacs Lake
Arndt

Minneapolis
Allen
Arndt
Dahl
Griffiths
Jensen
Parker
Pickett

Minnetonka
Dahl

Morris
Latner

Morton
Faust

Mountain Lake
Huie

New Ulm
Faust

Ortonville
Faust
Latner

Owatonna
Heberlein
Latner

Perham
Latner

Plymouth
Allen

Preston
Latner

Red Wing
Arndt

Redwood Falls
Faust

Roseville
Jensen

St. Cloud
Pickett

St. James
Huie

St. Paul
Arndt
Griffiths
Heberlein

Shakopee
Allen
Dahl

Soudan
Heberlein

Spicer
Arndt

Stillwater
Pickett

Taylors Falls
Heberlein

Two Harbors
Heberlein

Walker
Latner

Wheaton
Latner

Windom
Parker

Wolf Lake
Pickett

MINNESOTA 2000 photographers and the locations pictured in their works reproduced here:

JOSEPH ALLEN
Minneapolis, Plymouth, Shakopee

THOMAS ARNDT
Garrison, Mille Lacs Lake, Minneapolis, Red Wing, St. Paul, Spicer

STEPHEN DAHL
Hopkins, Maple Grove, Minneapolis, Minnetonka, Shakopee

CHRIS FAUST
Belle Plaine, Bloomington, Burnsville, Carver, Milan, Morton, New Ulm, Ortonville, Redwood Falls

GEORGE BYRON GRIFFITHS
Brainerd, Crosby, Deerwood, Edina, Minneapolis, St. Paul

TERRY GYDESEN
Apache Junction, Mesa, and Quartzsite, Arizona; Naples, Florida

DAVID HEBERLEIN
Caledonia, Lake Itasca, Marine on St. Croix, Owatonna, St. Paul, Soudan, Taylors Falls, Two Harbors

WING YOUNG HUIE
Butterfield, Mountain Lake, St. James

MARK JENSEN
Duluth, Knife River, Minneapolis, Roseville

PETER LATNER
Detroit Lakes, Henderson, Little Falls, Morris, Ortonville, Owatonna, Perham, Preston, Walker, Wheaton

DAVID PARKER
Minneapolis, Windom

KERI PICKETT
Falcon Heights, Minneapolis, St. Cloud, Stillwater, Wolf Lake

Minnesota in Our Time was designed and set in type at the Minnesota Historical Society Press by Will Powers. The text type is Adobe Chaparral, designed in 1997 by Carol Twombly. The photographers' prints were scanned as duotone images, printed in black and Pantone Warm Gray 3, and bound by Friesens, Altona, Manitoba. The paper is Warrenflo gloss.

A note on reproduction: With one exception, the digital files for this book's reproductions were created by scanning prints that the MINNESOTA 2000 photographers made expressly for this purpose. The reproductions of David Heberlein's photographs were made from 4-by-5-inch copy negatives created by the Minnesota Historical Society's Photo Lab from Heberlein's archive prints.